SCENES FROM UTOPIA

THE TEXAS HILL COUNTRY ARTWORK OF MARGIE BOTKIN

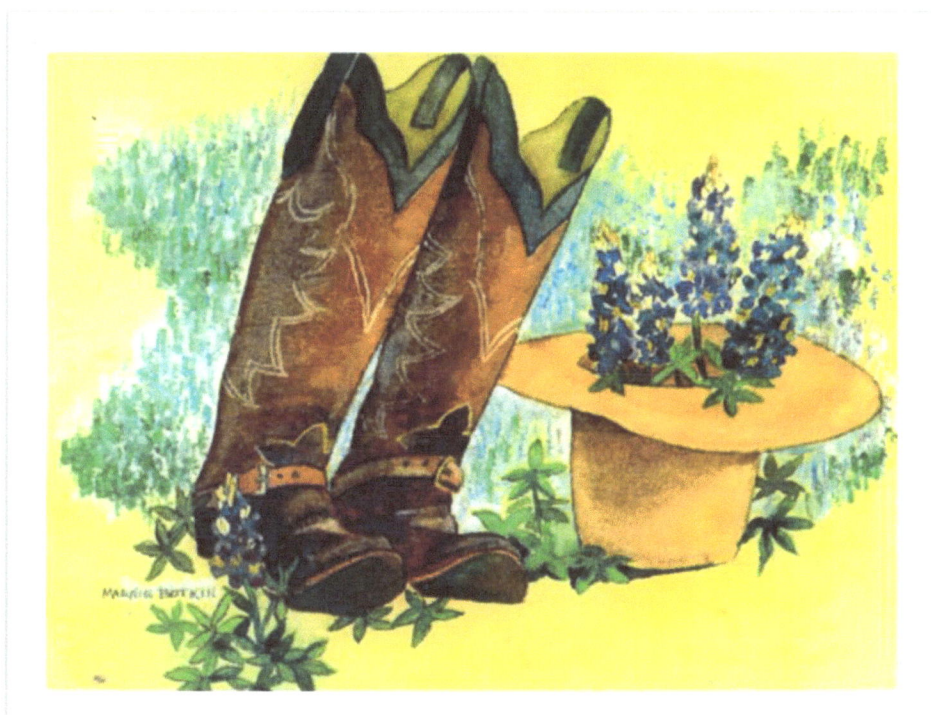

A Little Montana Book

Utopia, TX

copyright 2013 Margie Botkin

ISBN 978-1484038338

All rights reserved. This book or any portion thereof may not be reproduced or used in any manner whatsoever without the express written permission of the publisher, except for the use of brief quotations as in a book review.

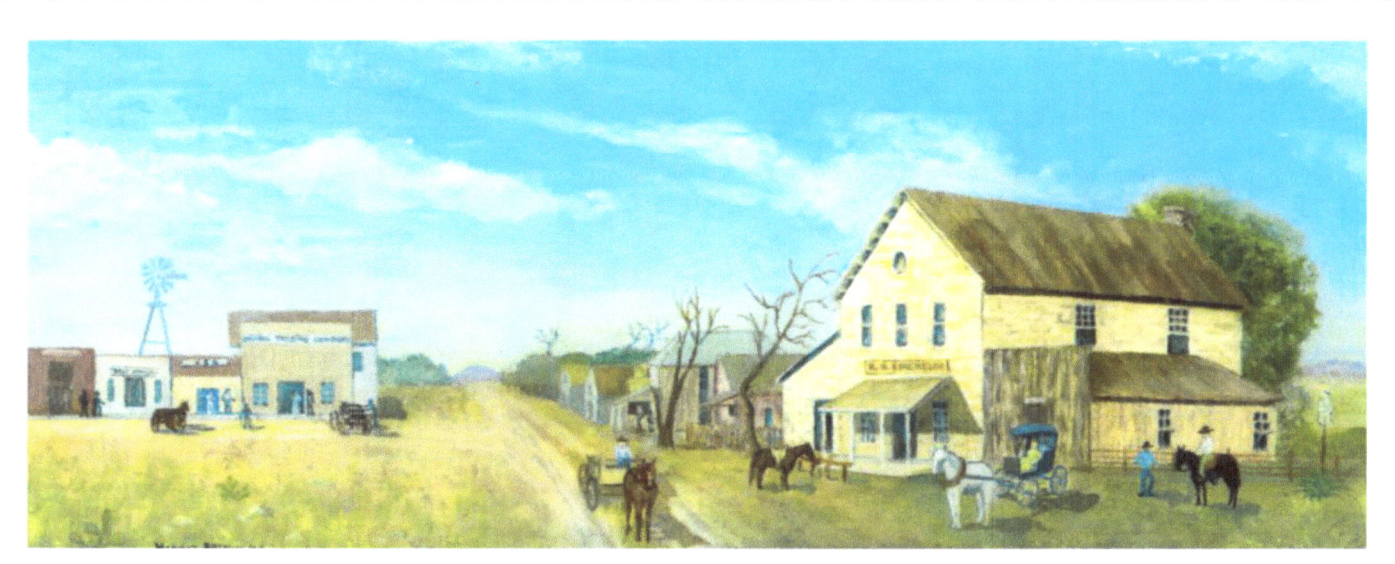

UTOPIA

Robert Kincheloe may be regarded as the founder of the town of Utopia. In 1873 he built a substantial rock store and home of two stories, which was the first business in the present town site. A town was later laid out. The Kincheloes then began the sale of town lots, and other businesses and residences were soon constructed. The Kincheloes gave acreage and lots for a park, churches, and to several ministers who wished to remain permanently in the peaceful community.

The post office was moved from Waresville to Utopia in 1884, and for a time the town went by the name of Montana (from the Spanish montaña for mountain). This was in the first recorded plat in the records of Uvalde County, Texas. Later it was learned that there was another post office in the state similarly named and the name was changed to Utopia. The proposed name originated no doubt from Sir Thomas More's *Utopia*, an ideal place of political or social perfection.

The second story of the Kincheloe building was removed in 1946 by Paul Redden. The Sid Mauldin family bought the store, later named Utopia Builders Supply, in 1961.

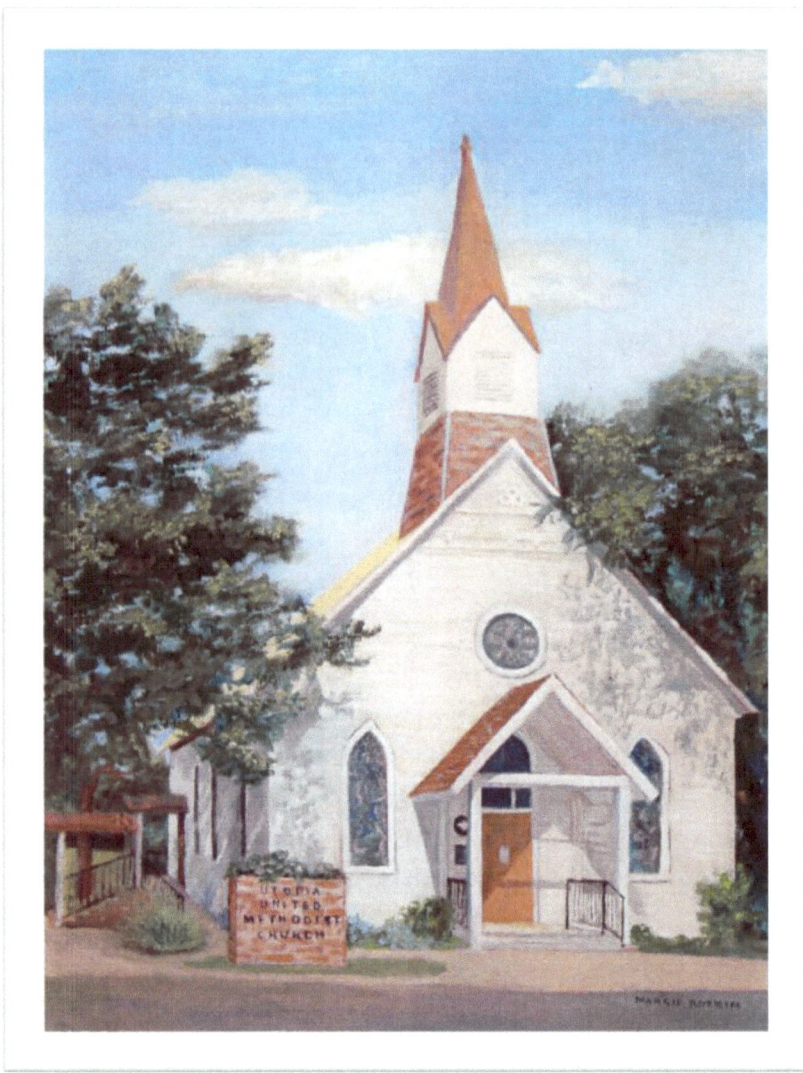

UTOPIA UNITED METHODIST CHURCH

When the church was built in 1892, members did much of the work. The church was built on land donated by R.H. Kincheloe and the Rev. Irvin Jones.

UTOPIA BEAUTY SECRETS

Lindy and Alyssa Padgett rode their horses into town for haircuts.

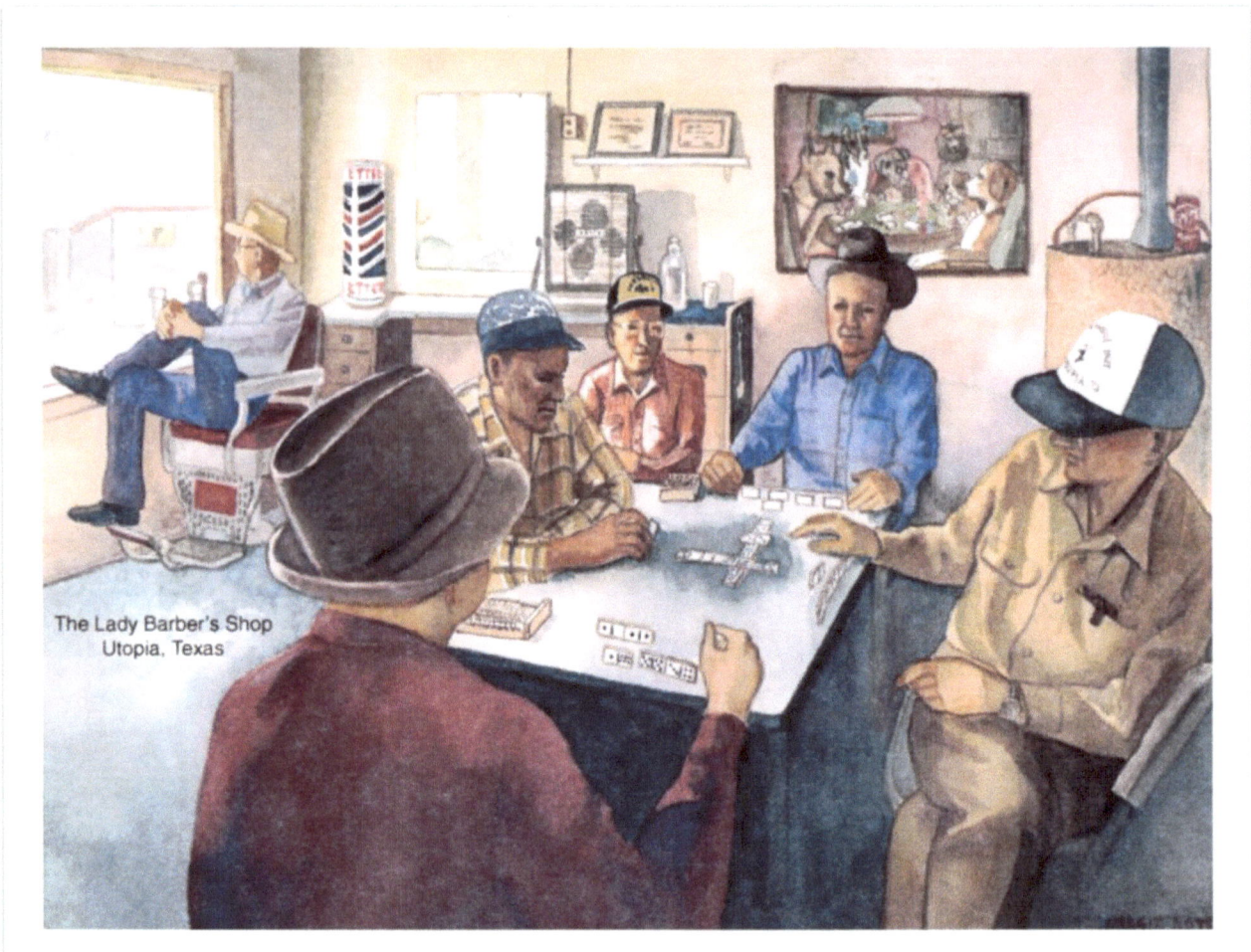

THE DOMINO HALL

For many years, this building in Utopia served as the barber shop for Viola Reavis Clark. After she hung up her clippers, it became the site for many ongoing domino games. Clyde Cornelius, Ira and Oscar Gazaway, Lee D'Spain, Allen Tampke, and Drew Reavis (the barber's brother) whiled away the lazy Utopia afternoons.

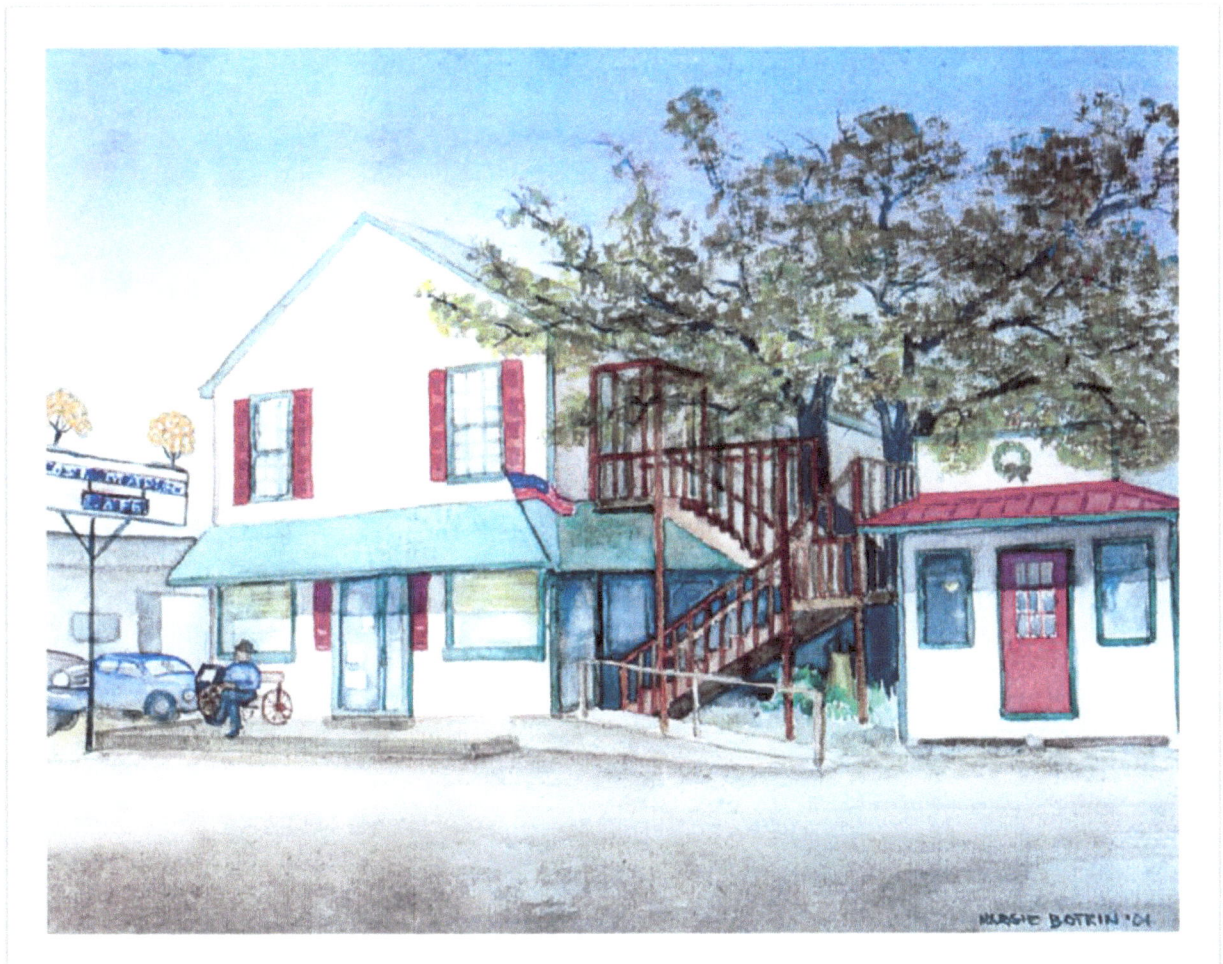

LOST MAPLES CAFÉ

Built sometime before 1904, this restaurant is named for a grove of non-native maple trees of mysterious origin. It was formerly a Masonic Lodge, a doctor's office, a drugstore, and a classroom for college courses. Owned and operated by Tacy and Rusty Redden since 1986, the restaurant is known for its pies.

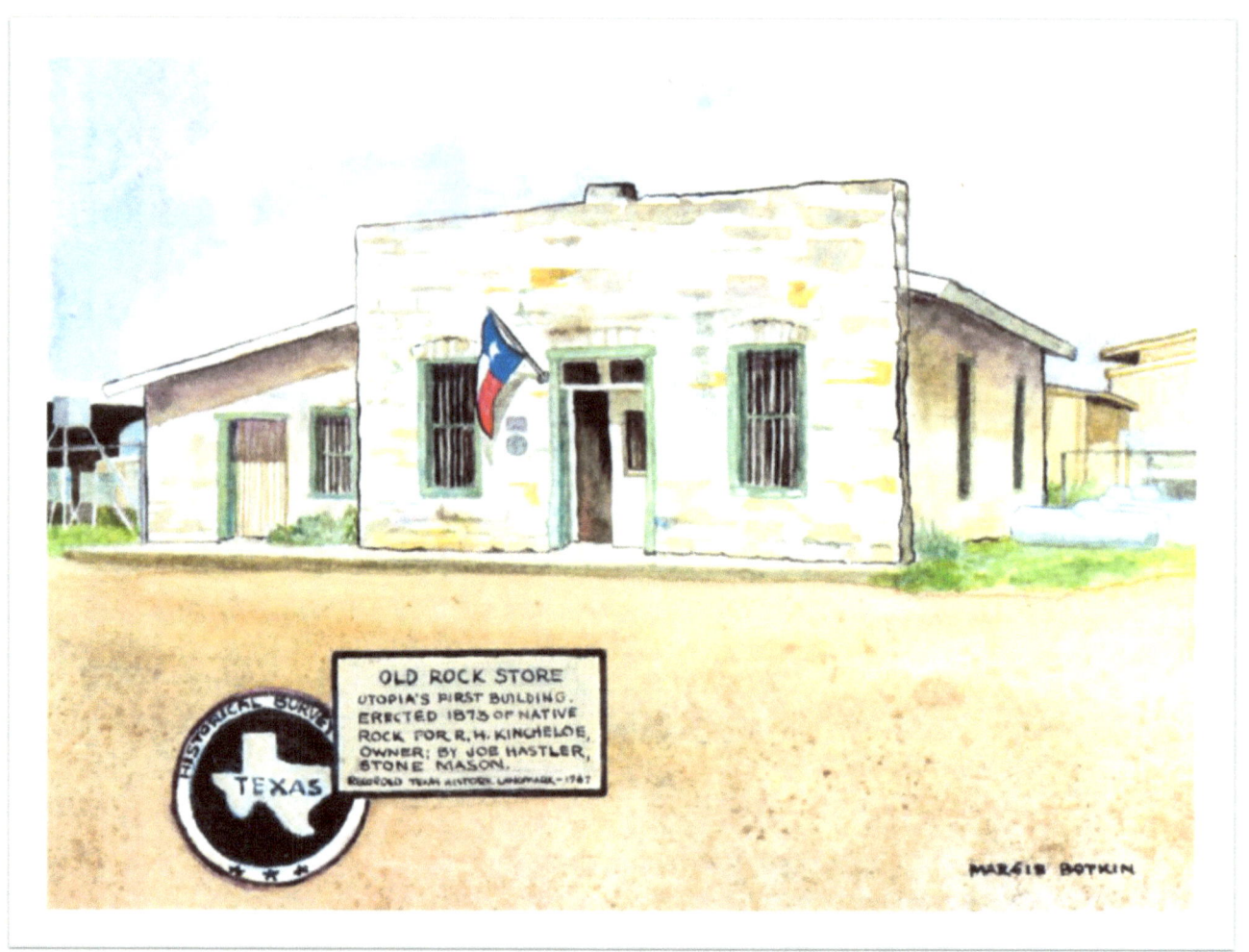

UTOPIA BUILDERS SUPPLY

A second story was removed. An original rock engraved with RHK 1873 (R.H. Kincheloe) adorns the top front rock wall. The store has been owned by the Sid Mauldin family since 1961.

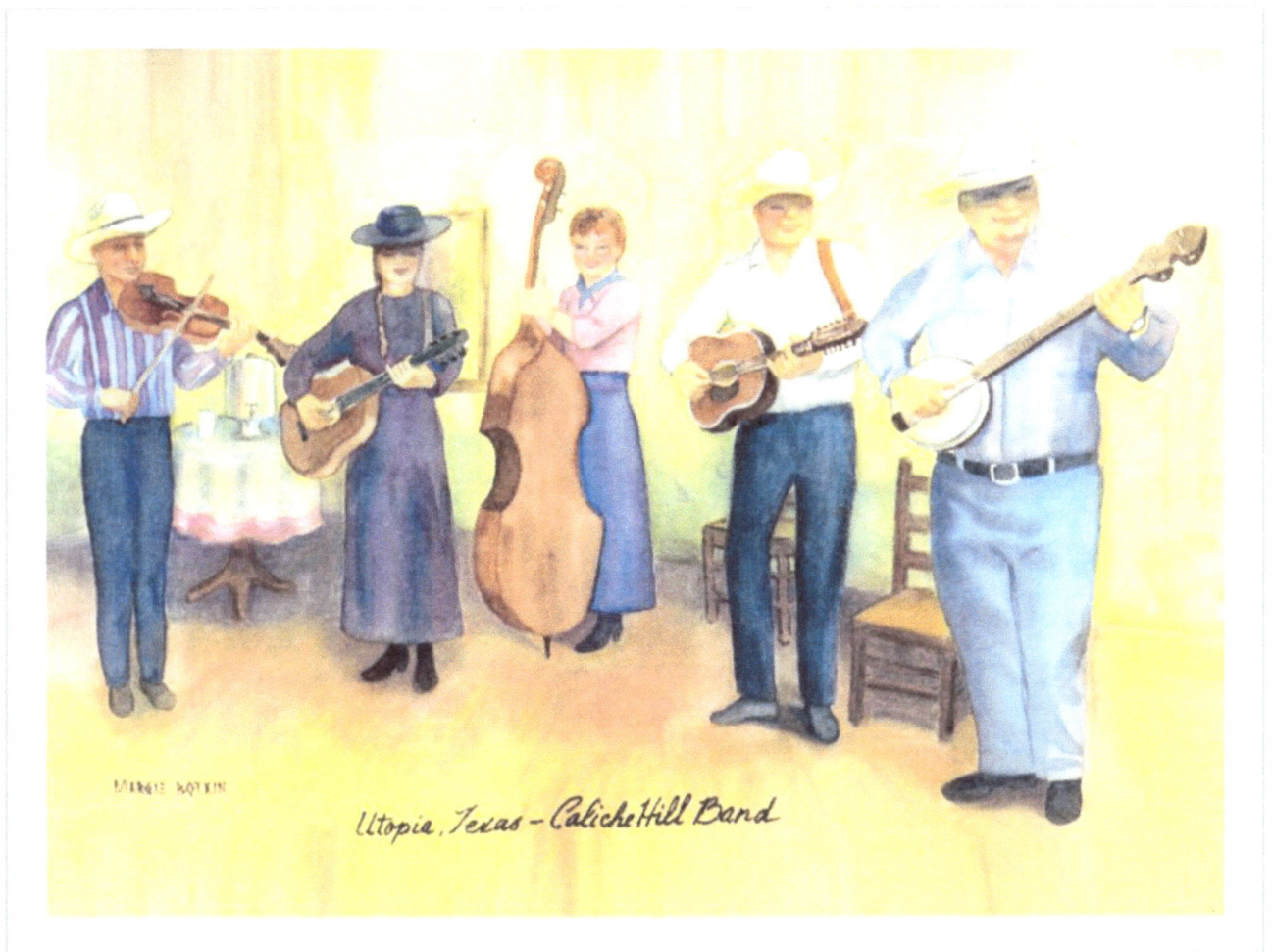

CALICHE HILL BAND

Tom Bomer, Linda Burton, Marge Wadkins, Bill Schaefer and Bobby Thompson were members of this band, which was started by Schaefer and played in his car shop on Saturday afternoons, attracting townsfolk who came to enjoy the music.

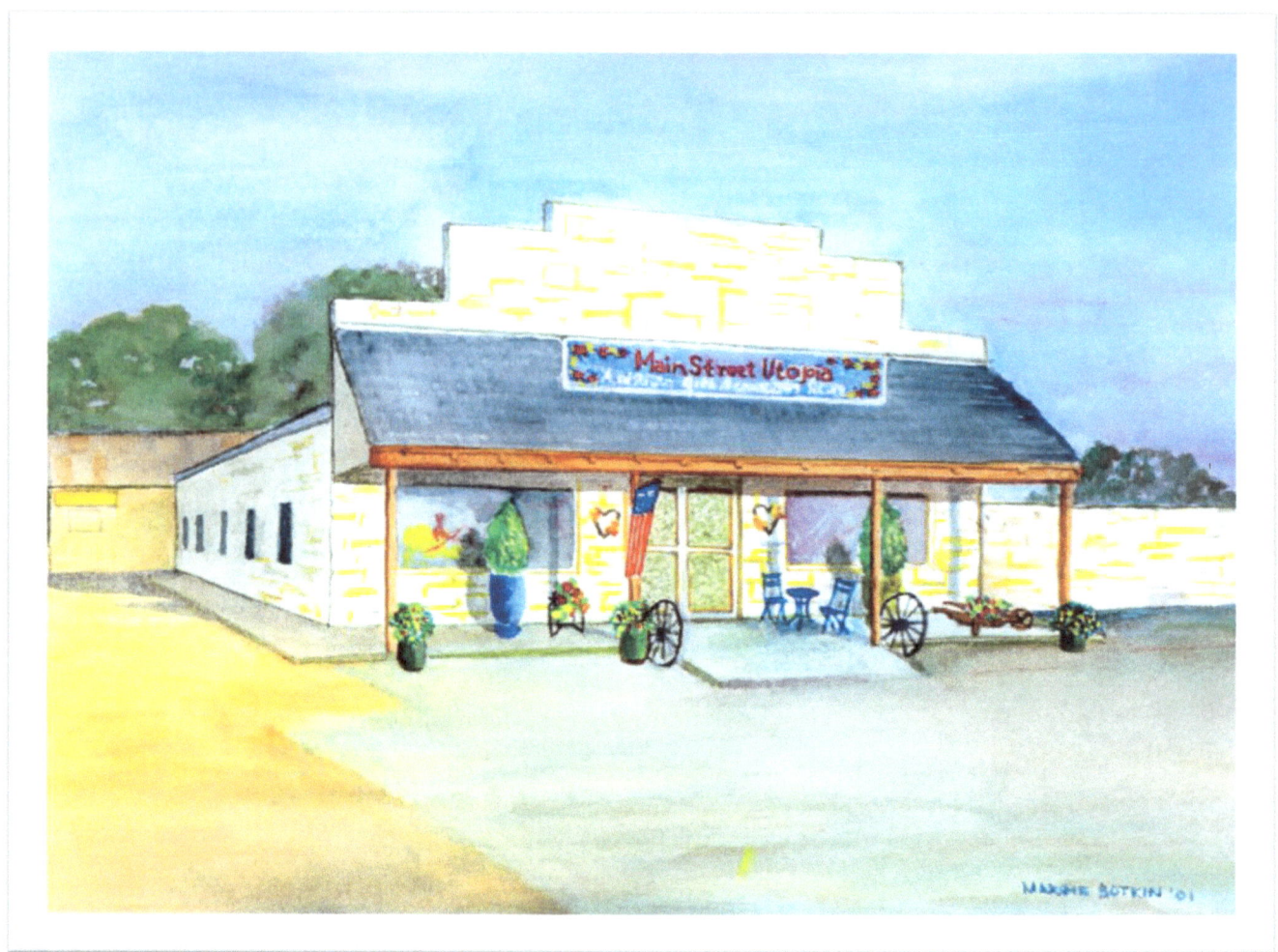

MAIN STREET UTOPIA

This shop in a rock building near the southern end of town sells antiques, consignments, and special finds from France.

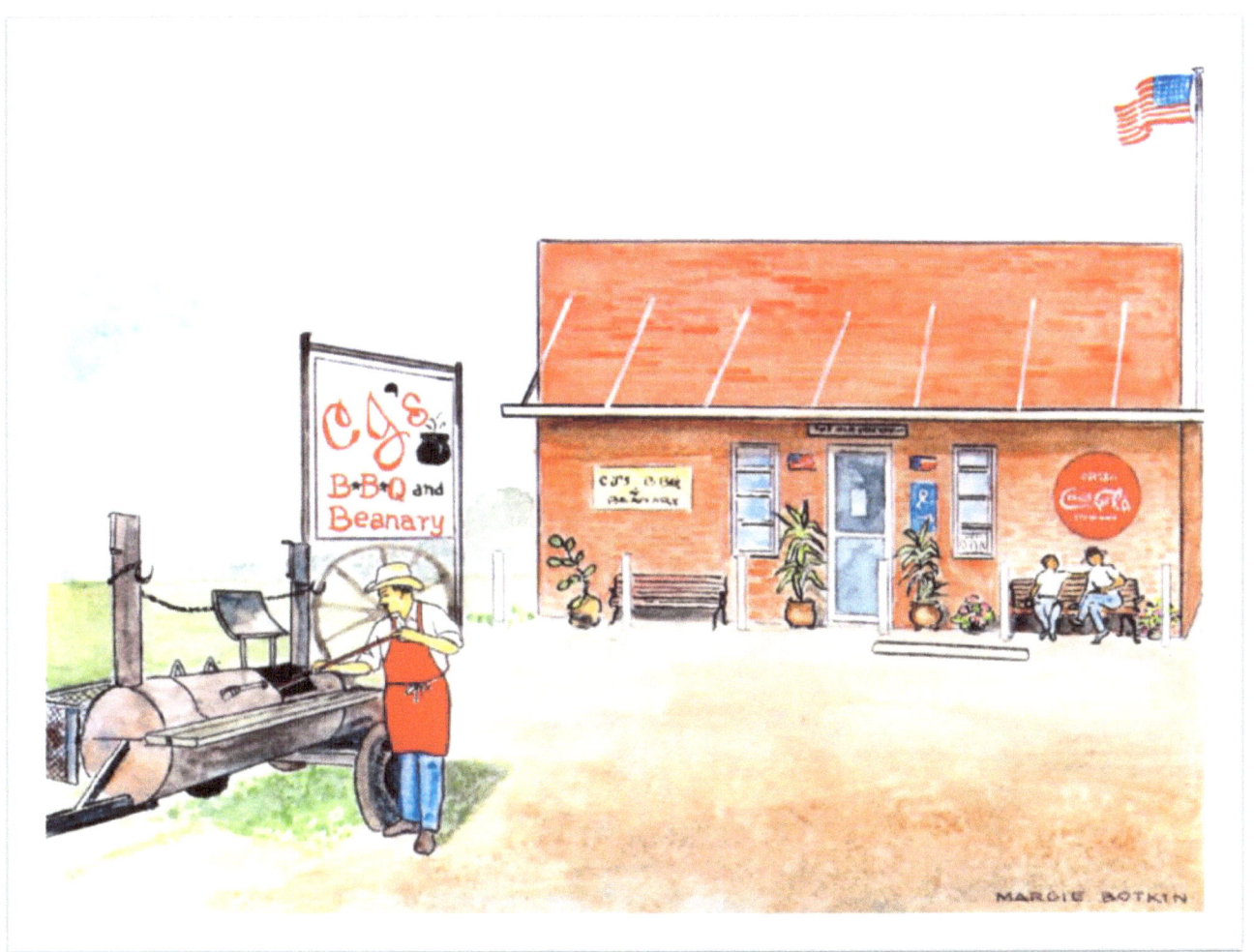

CJ'S BBQ AND BEANERY

This business was in the old post office building in Utopia, and was owned by Carole and Jimmy Mangum.

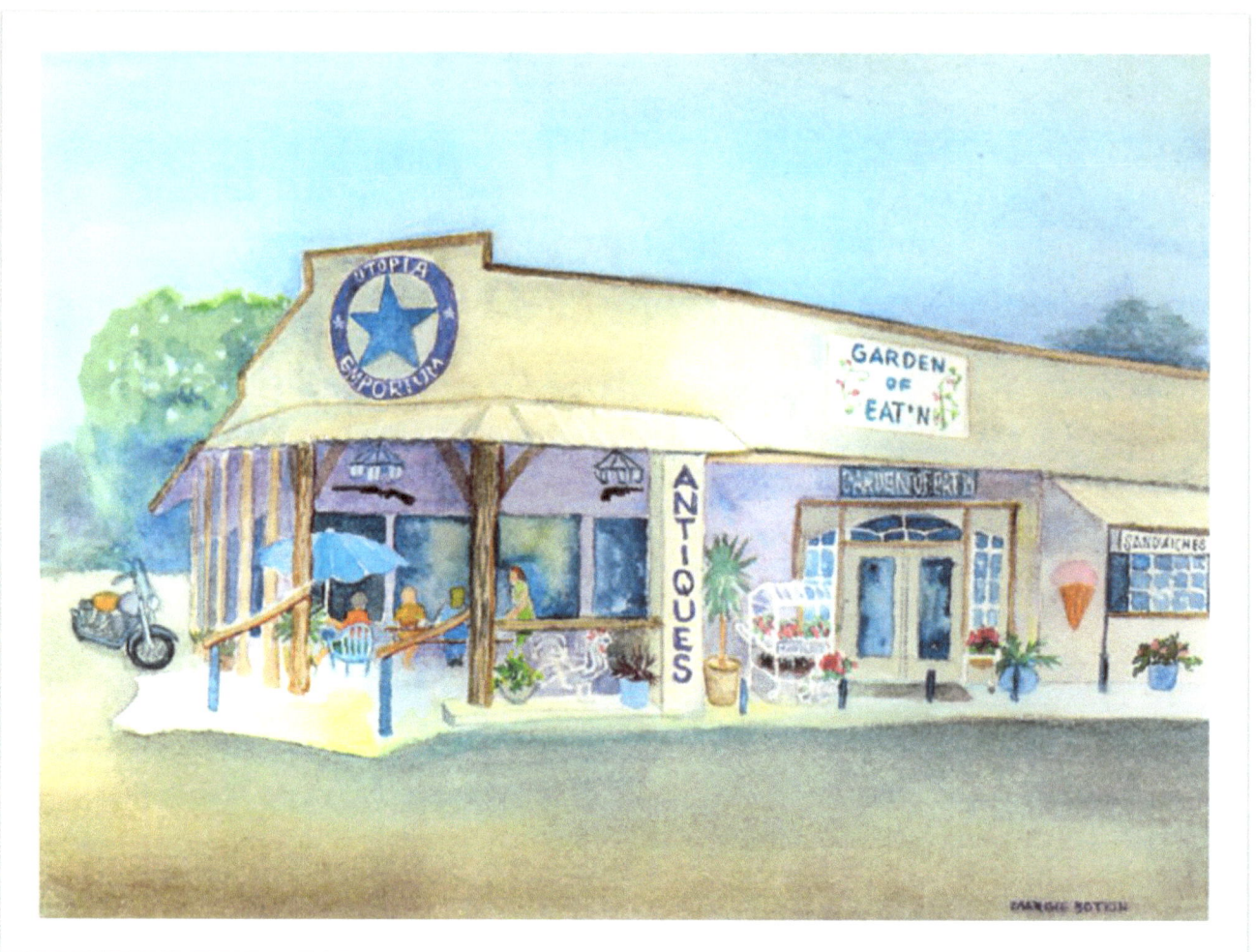

UTOPIA EMPORIUM

Antiques, firearms, and the Garden of Eat'n restaurant could all be found in this building.

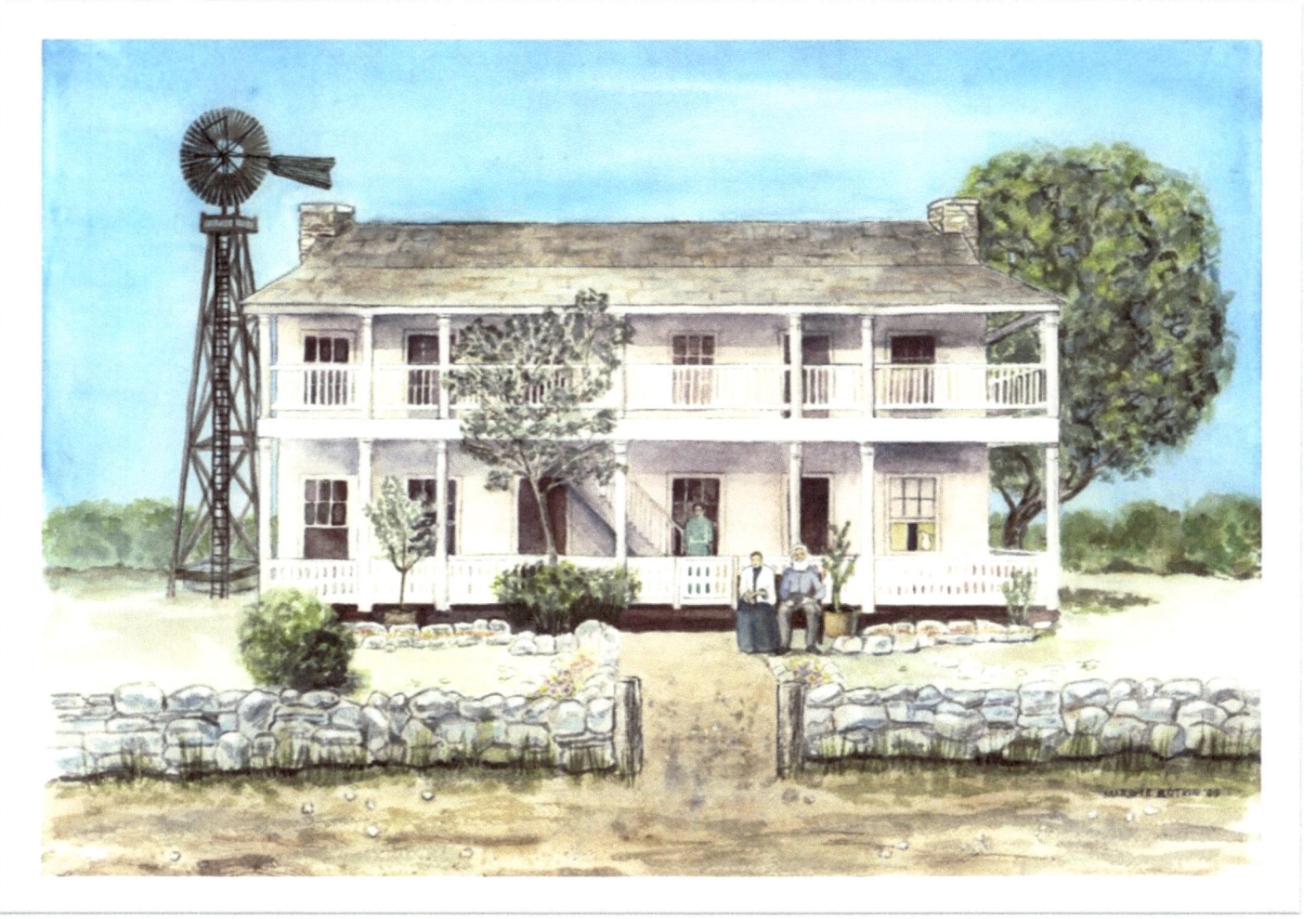

JOHN CRANE WARE HOUSE

Built in 1869-1870, then burned in 1929, the house was rebuilt by his daughter, Leobel Ware, in 1933. The Family Land Heritage Program award the Texas Historic Farm designation for being in continuous agricultural operation by the same family for 150 years.

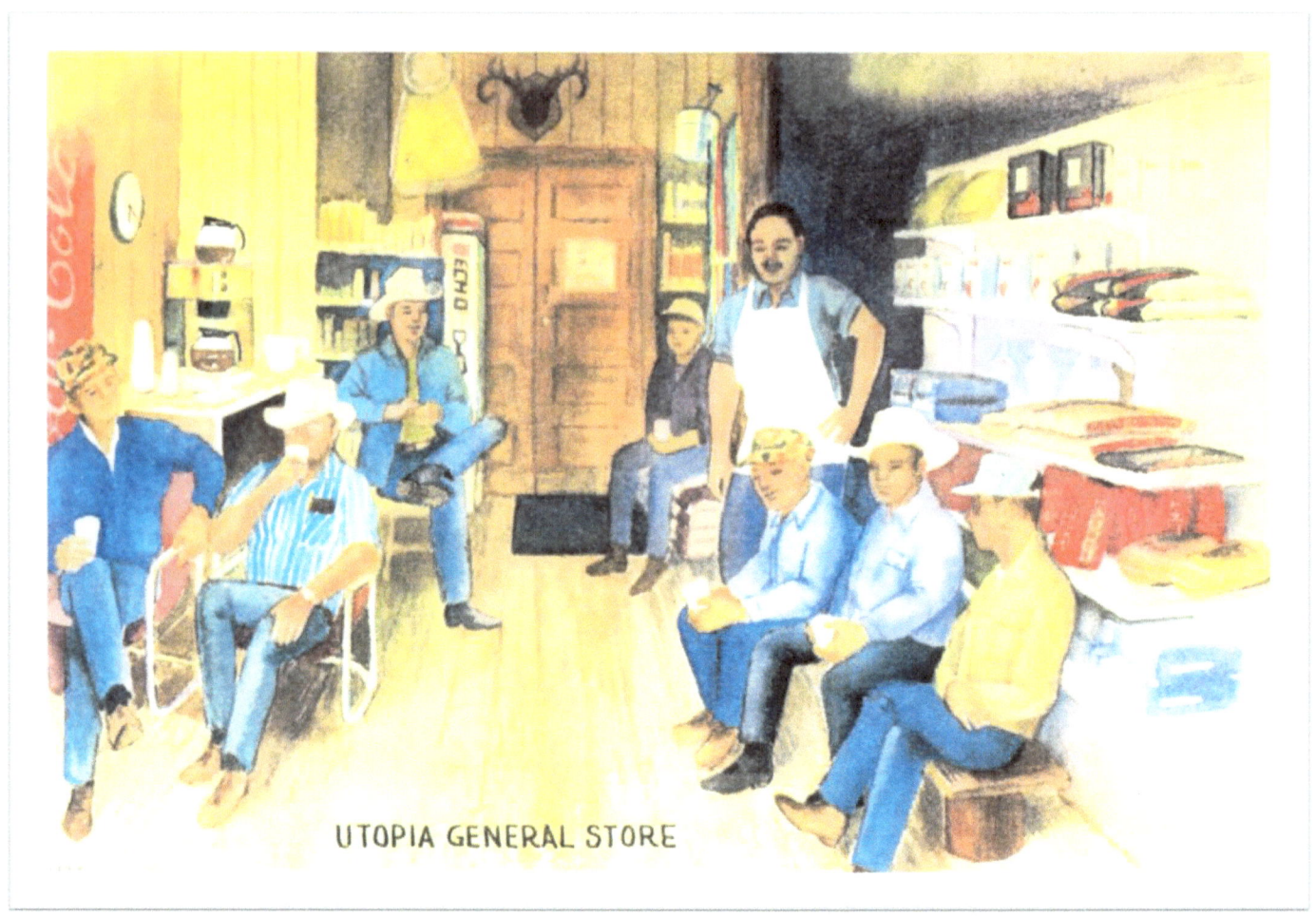

UTOPIA'S GENERAL STORE

(L to R) Ralph Boyce, John Hillis, Tony Clark, O'Neill Stuart, Morris Killough, Albert Tampke, Willard Jacobs, Charlie Baumer

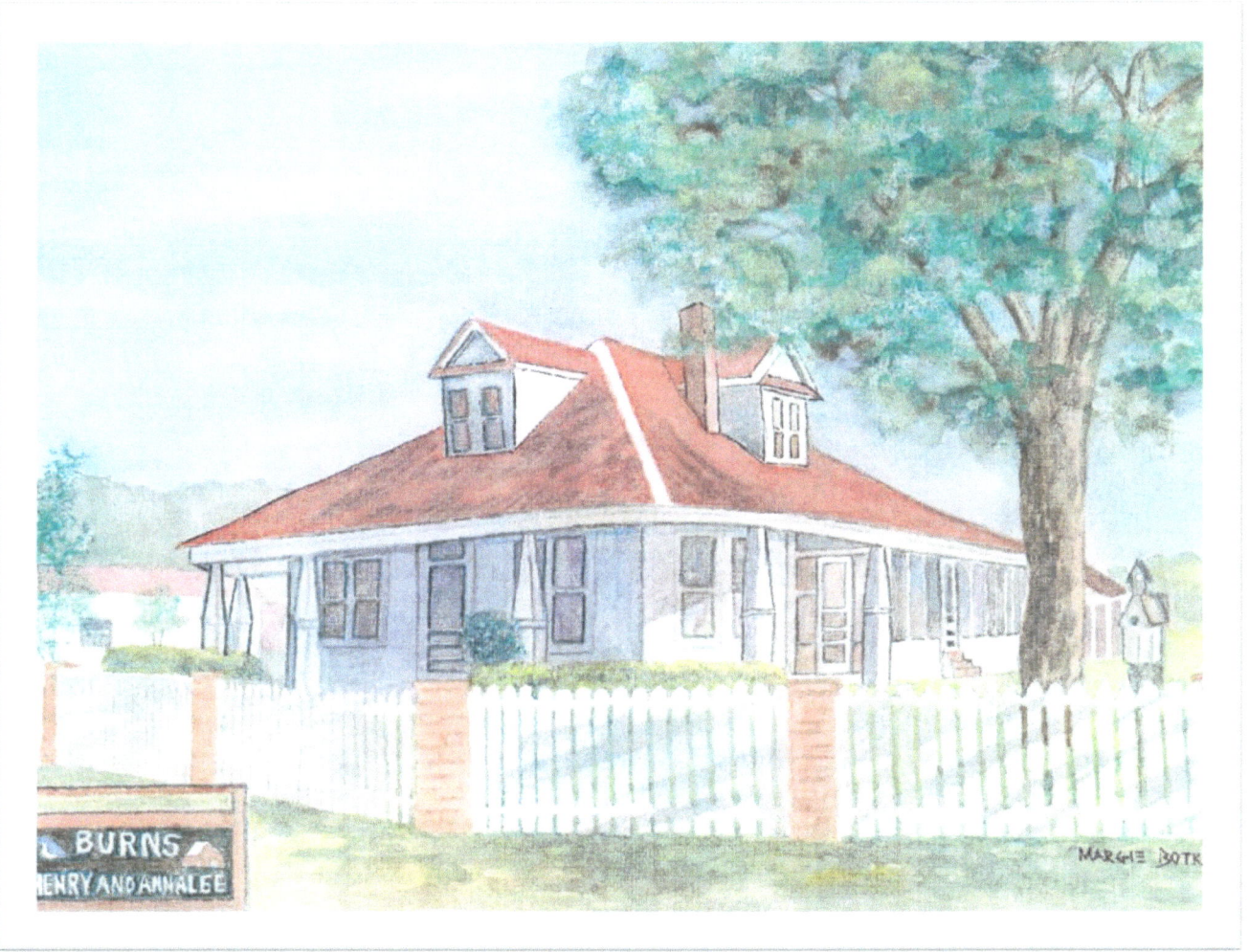

SEARS ROEBUCK HOME

This Sears Roebuck home was shipped to Sabinal by rail and was delivered to Utopia by mule wagon. The house was assembled by L.D. Bownds in 1912. Purchased by Henry and Annalee Burns in 1967, the home is still owned by their children. Mrs. Burns wrote articles and books documenting the history of the Sabinal Canyon area.

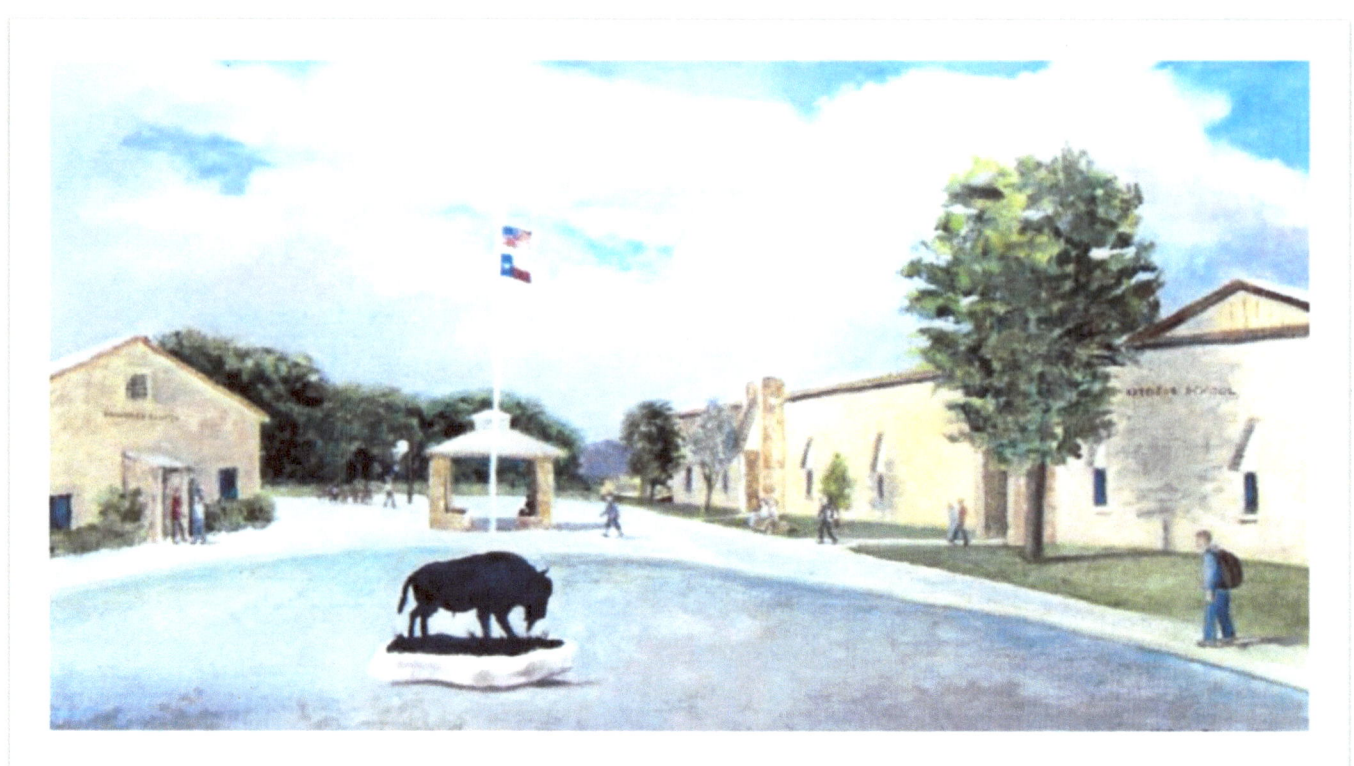

UTOPIA SCHOOLS, HOME OF THE BUFFALOS

In 1880 the first schoolhouse was built. About 1906, the old building was torn down and replaced by a new two-story frame structure. That building burned in 1925 and the current building was constructed.

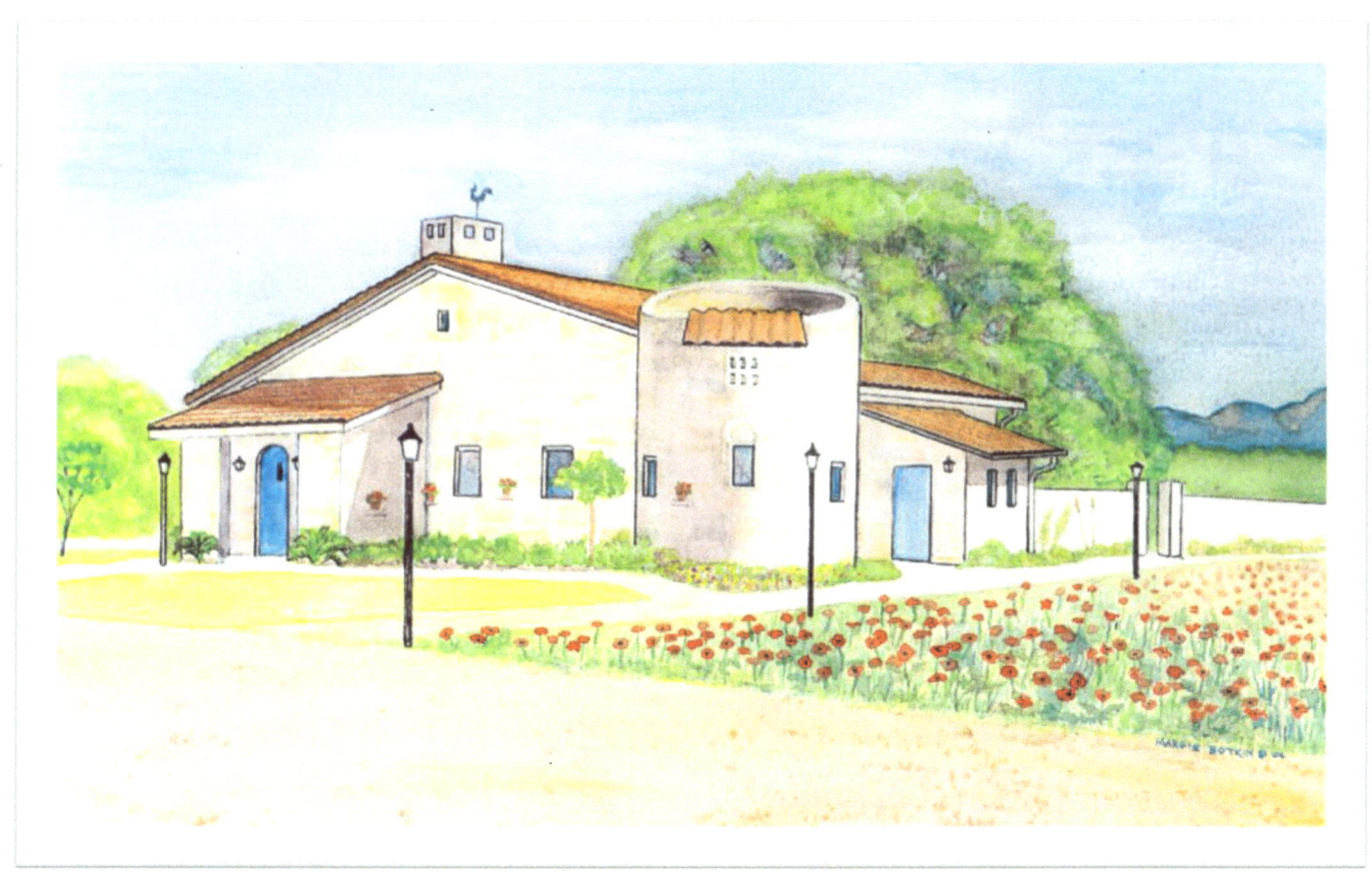

THE LAUREL TREE RESTAURANT

A charming eatery in a European-style rock building. The owner and chef, Laurel Waters, trained at Le Cordon Bleu in France.

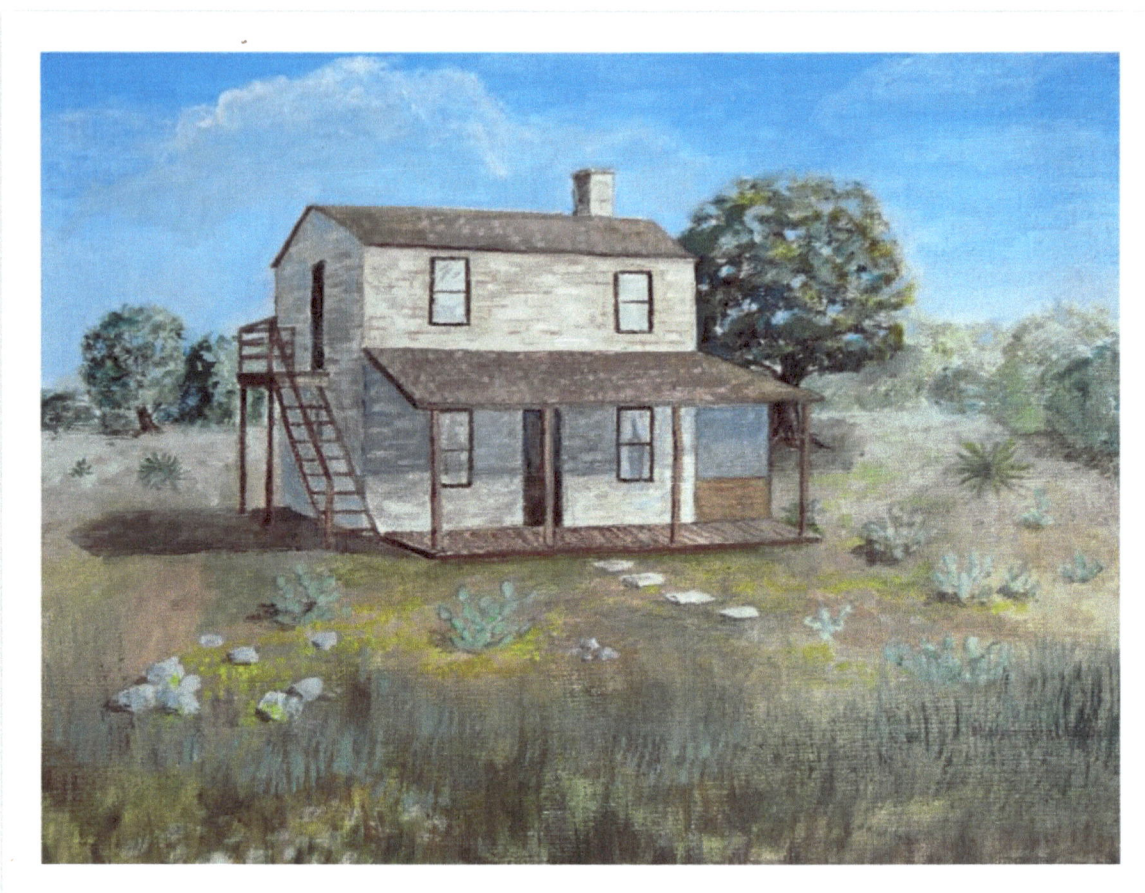

FARM HOUSE ON MONTANA RANCH, UTOPIA

This 160-acre ranch was originally granted to H. D. O'Brien (Hiram Duncan O'Bryant) and his heirs on Jan. 4, 1878 by the state of Texas. The Kickapoo Indian raid had taken place on this ranch on Oct. 11, 1866, when Mrs. Kincheloe was lanced and speared 17 times but survived. Soon after the tragic Indian attack, these people left their home on Little Creek and moved to a new location in Montana (now named Utopia).

Stone mason Joe Hastler built the old rock store in 1875 for R. H. Kincheloe. He later built this two-story chalk rock home where Albert Love Tampke and his wife, Mary Elender O'Bryant Tampke, lived and raised a family for 70 years. Since O'Bryant, the ranch has been owned by Tampke, Anderson and Bunting, Potts, and Botkin.

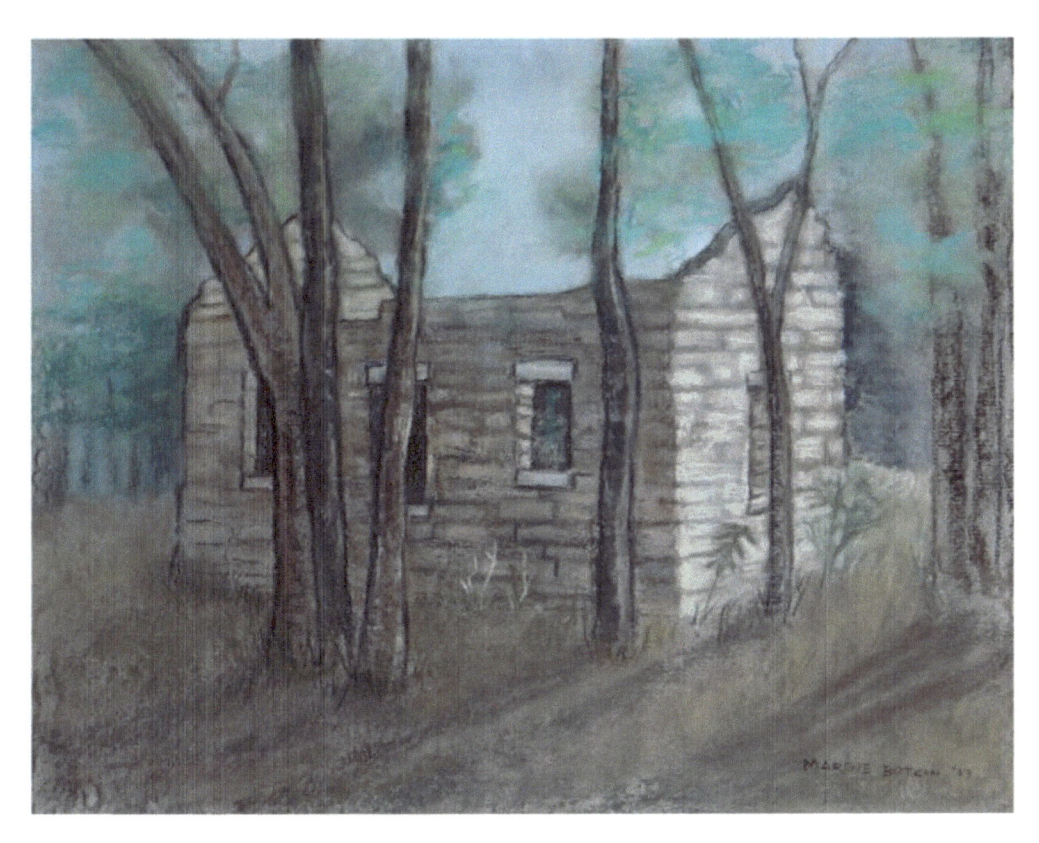

OLD ROCK HOUSE, MONTANA RANCH, UTOPIA

"In the name of the State of Texas, this 160-acre tract was granted to H. D. O'Brien (Hiram Duncan O'Bryant) and his heirs on Jan. 4, 1878… Situated in Bandera County on the waters of Turkey Creek (now known as Little Creek) about 23 miles W. from Bandera City."

Hiram's nephew, Hiram William O'Brien (who changed the spelling from O'Bryant) and his wife Emily built this rock house and lived in it for two years. The children had to walk through a lot of woods to go to school. Apache Indians roamed the area, so Emily was frightened and would not let the children play out of doors while Hiram was at work. They moved back to Lower Lake, California.

No one knows much about this house, but the story goes that Indians burned the roof.

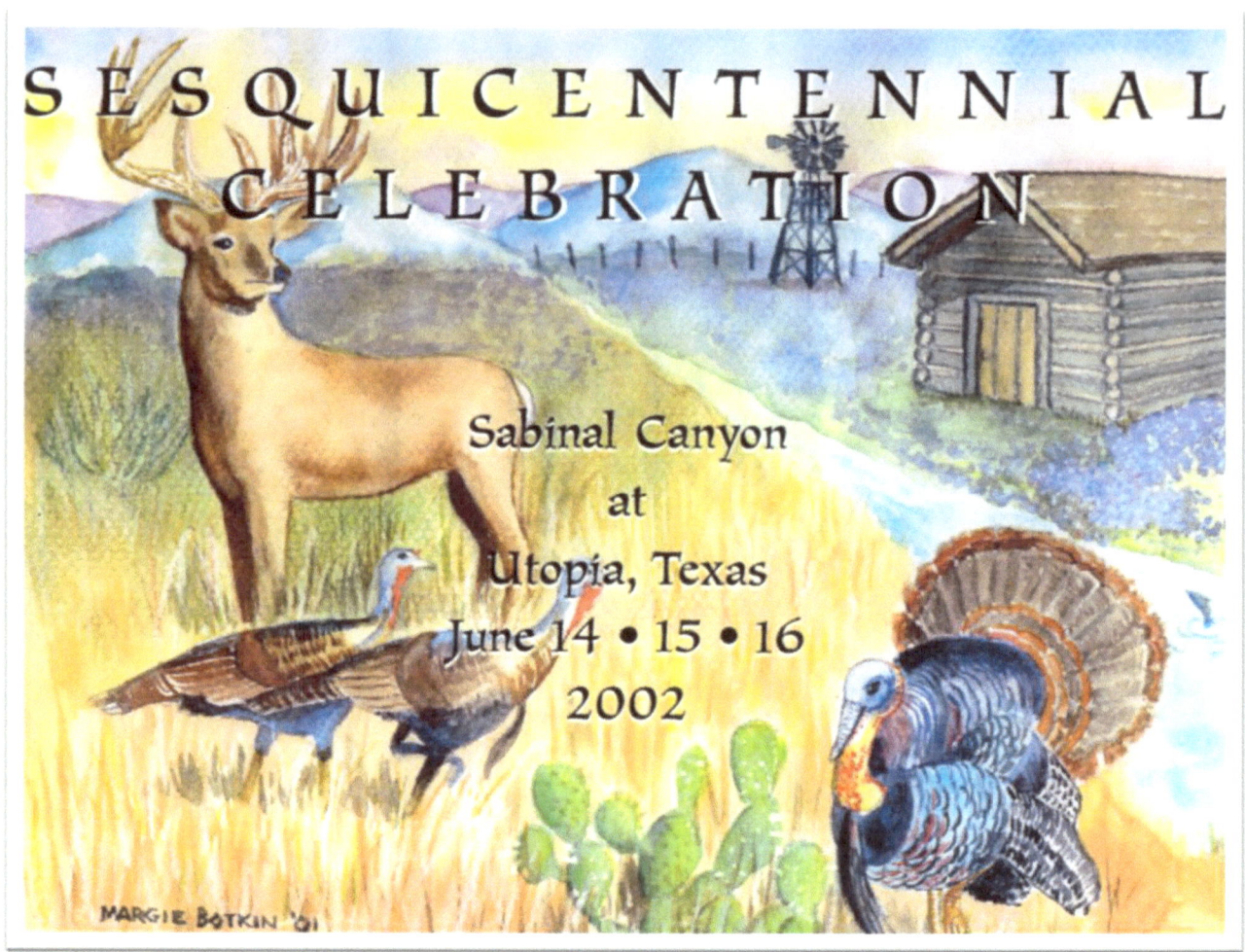

SESQUICENTENNIAL CELEBRATION

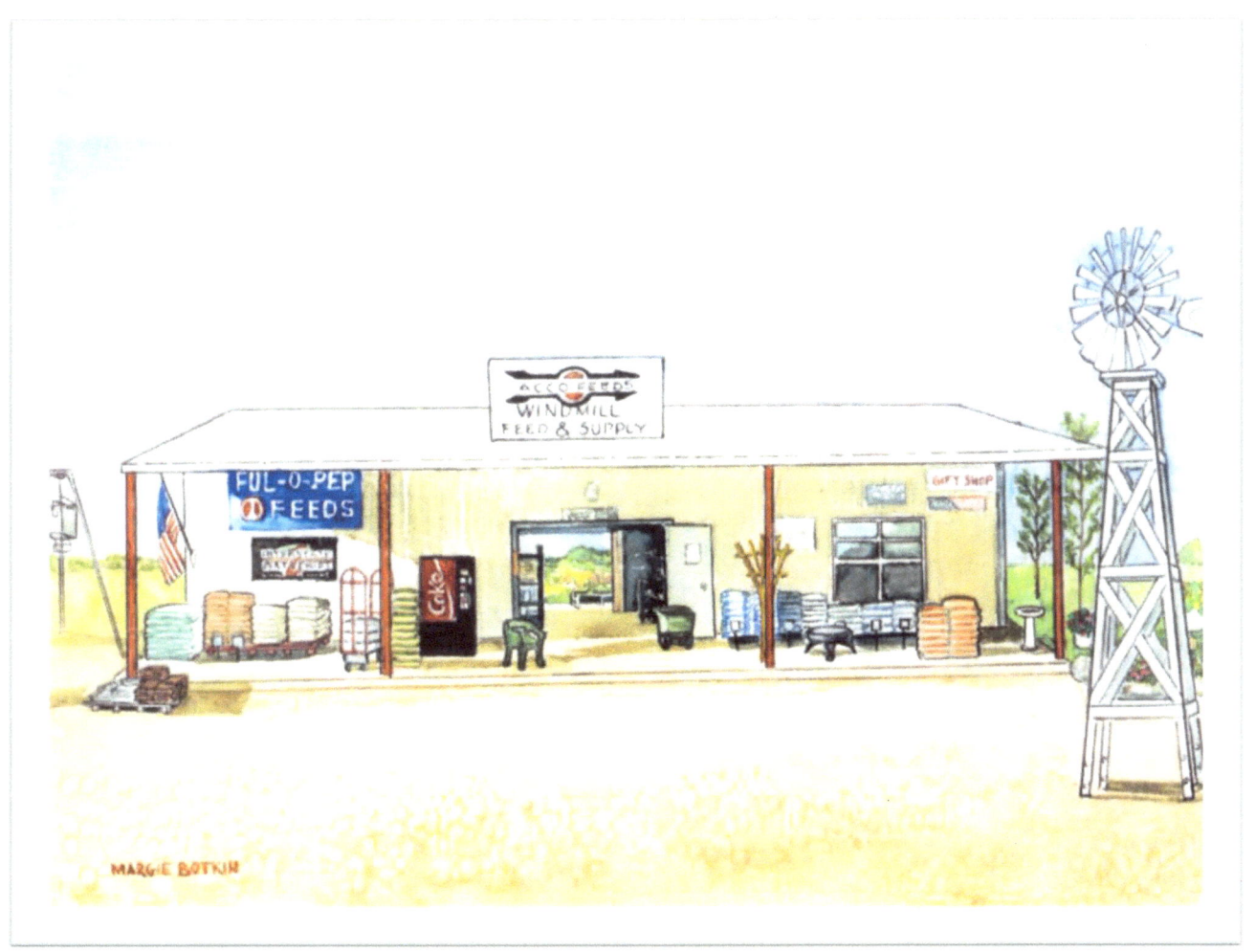

WINDMILL FEED & SUPPLY

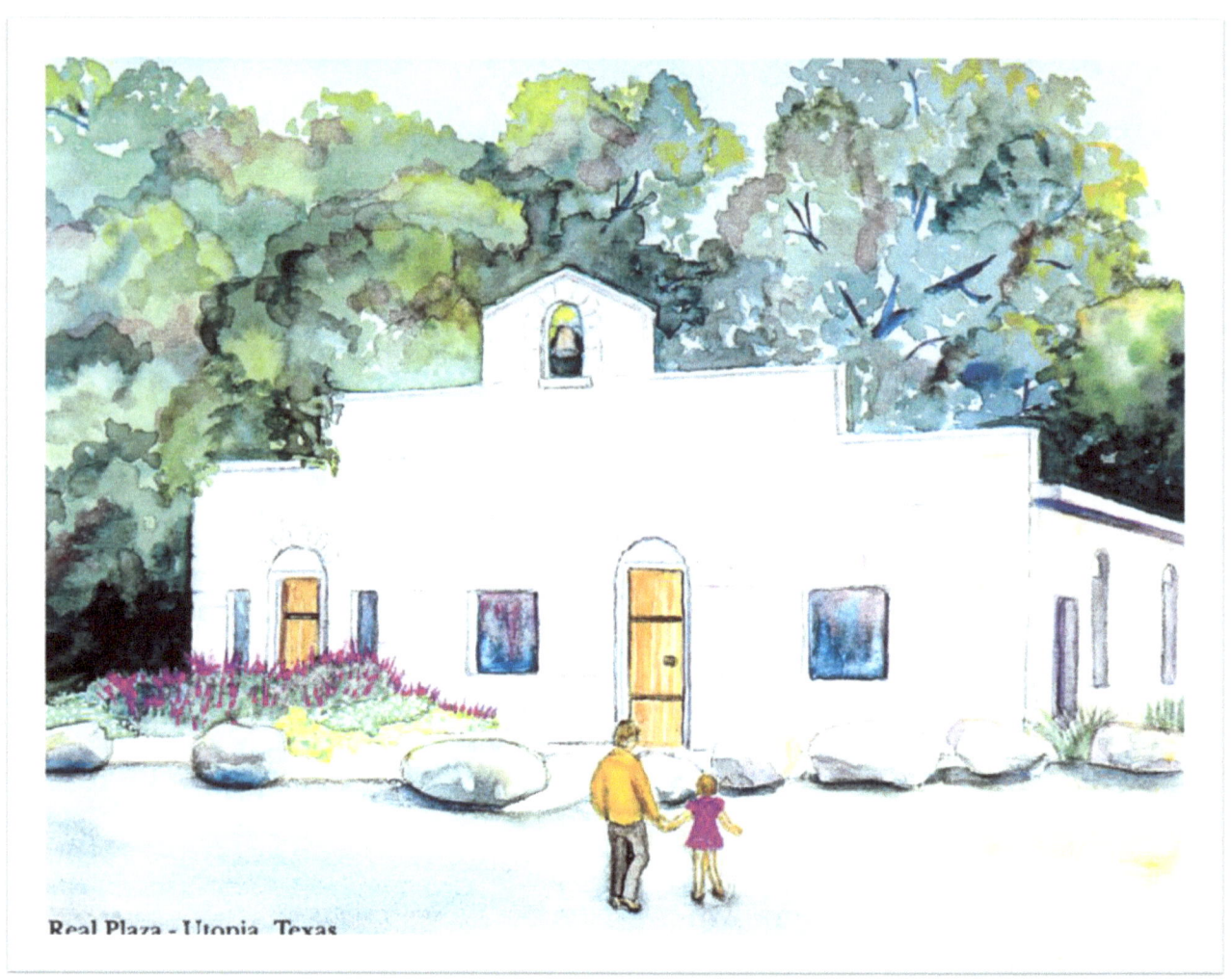

REAL PLAZA

Early in the 1900s, this was the site of Utopia's blacksmith shop. Neighbors came to collect sweet water from the town's best well, and ice cream socials were often held under the trees on Sunday afternoons. Restored in 2002 as the headquarters of Utopia's Sesquicentennial Celebration, the plaza was named to honor Lillian and Felix Real for their work in beautifying the town of Utopia.

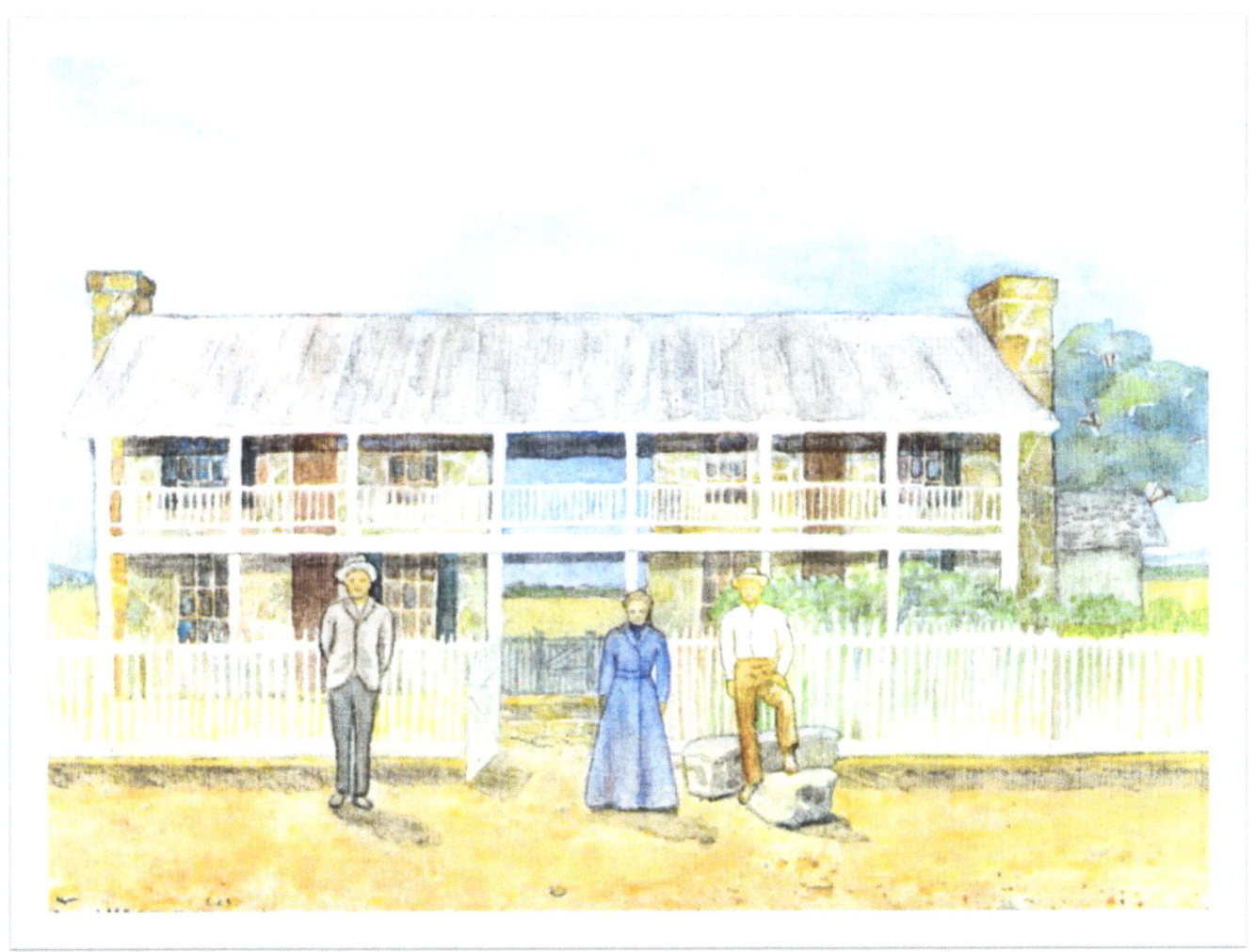

FENLEY DOG-TROT HOME

This house in Waresville (later called Utopia), built in 1872, was the home of Joel Daniel Fenley, his wife Eliza Ware Fenley, and their six children. On more than one occasion the sturdy stone house held every man, woman, and child in the community while Native Americans raided the area.

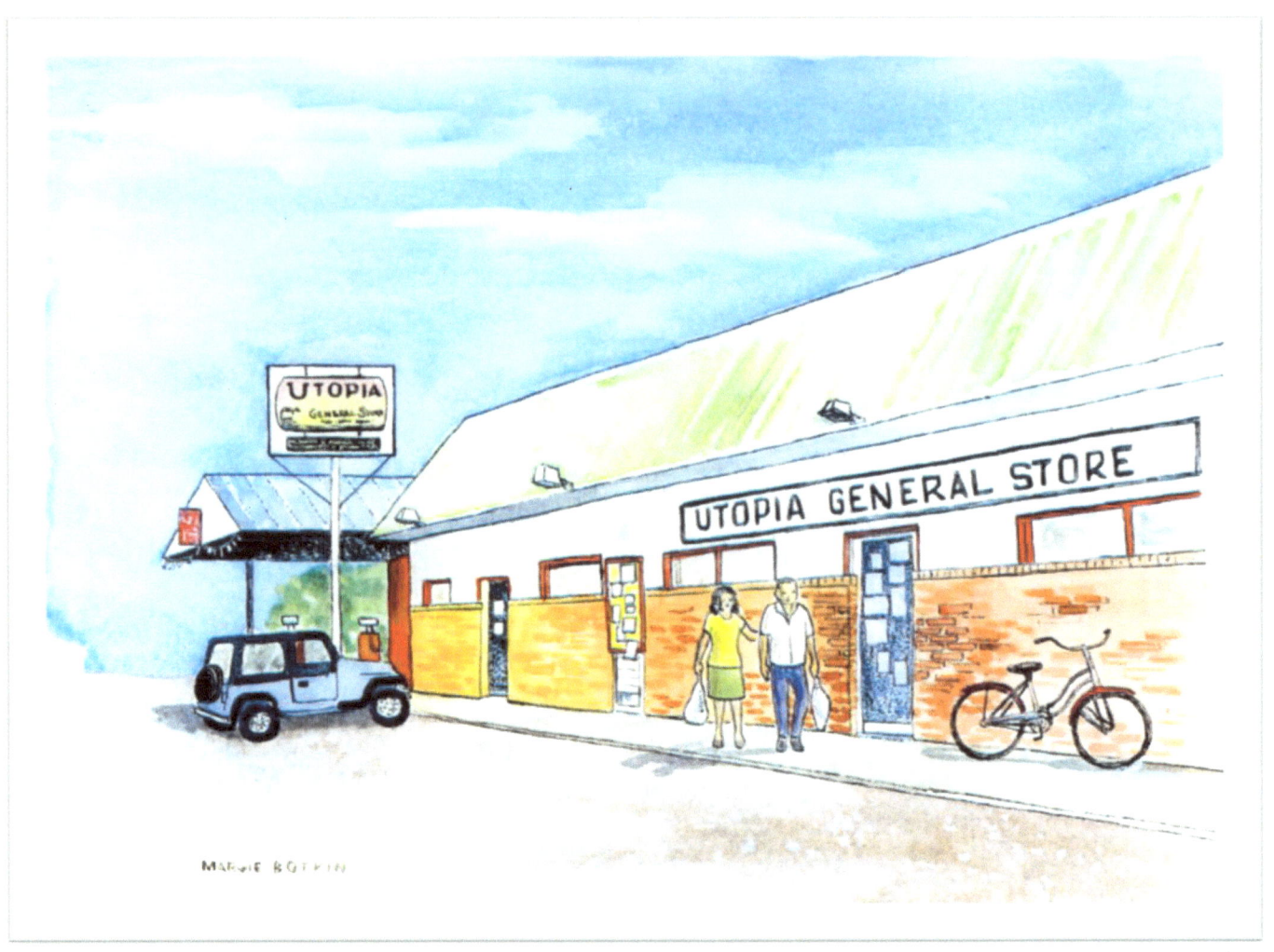

UTOPIA GENERAL STORE

Established in 1952, Utopia's only grocery is a source of local information as well as of food.

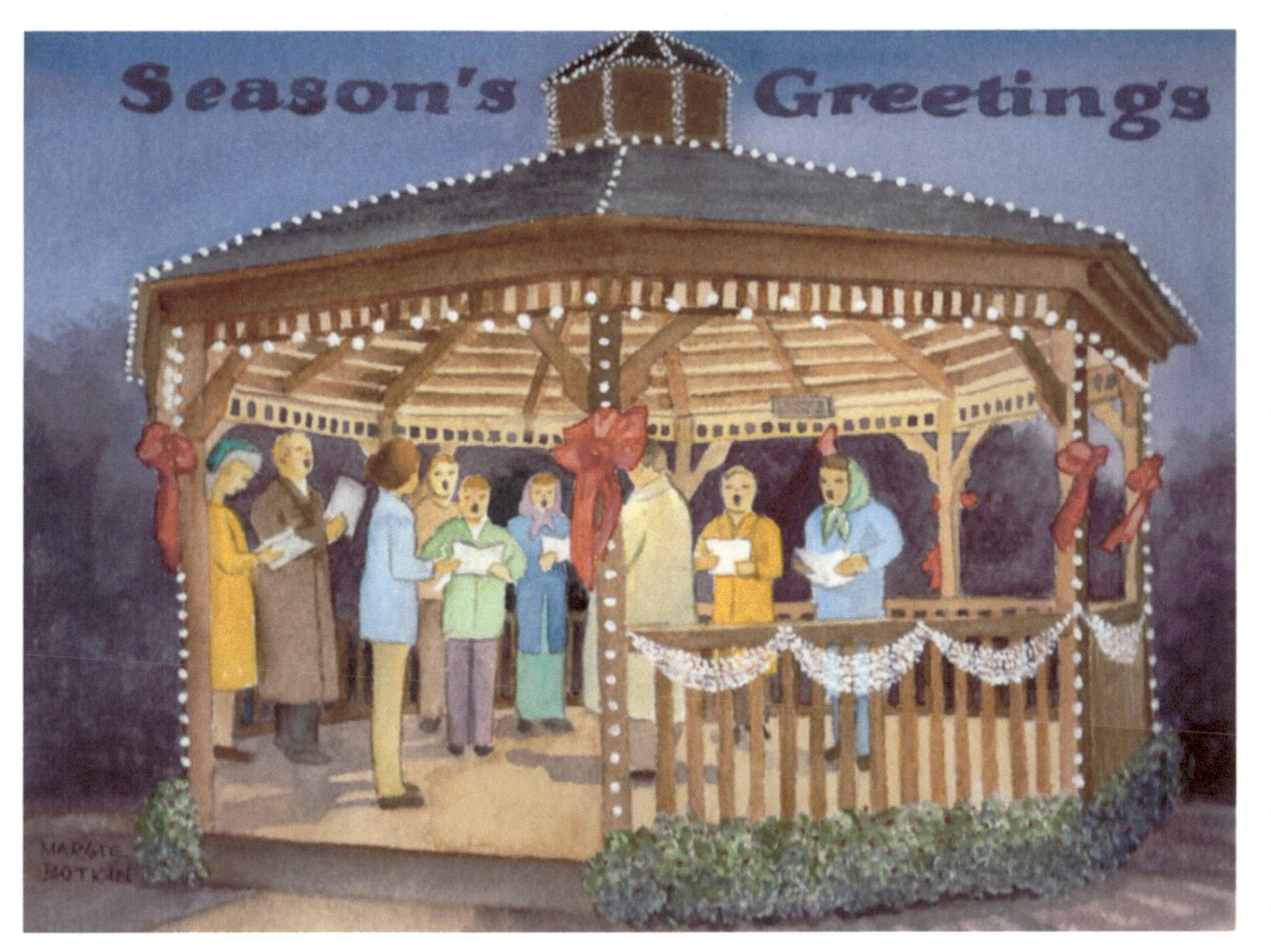

GAZEBO

This gazebo, situated in the center of San Jacinto square in downtown Utopia, was donated by Kay & Ben Barrow in April 2000.

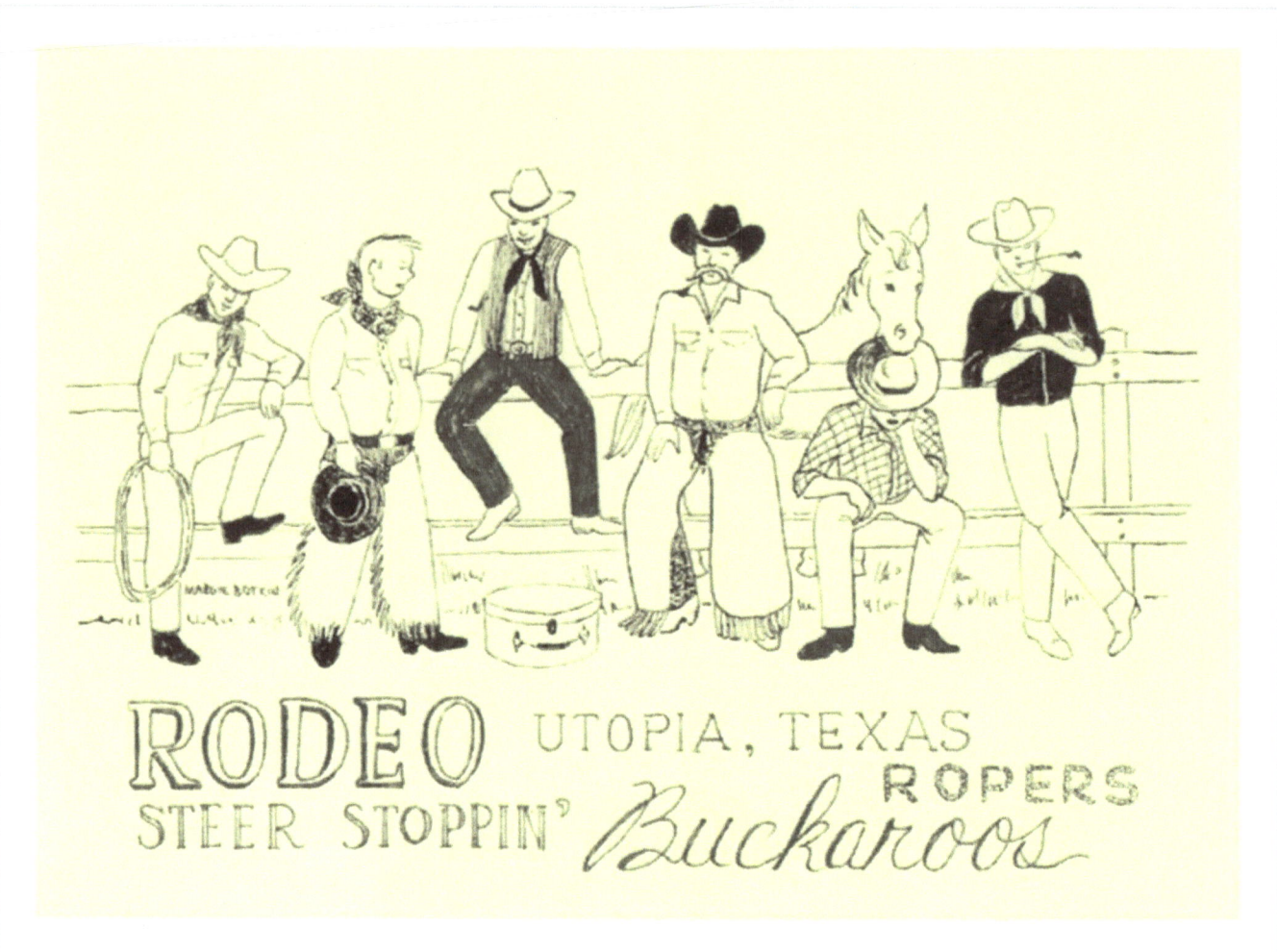

UTOPIA RODEO

The local rodeo is held annually on the fourth weekend of June at Utopia Park. A professional rodeo, produced by Mike Outhier, is held annually on the Sunday of Memorial Day weekend.

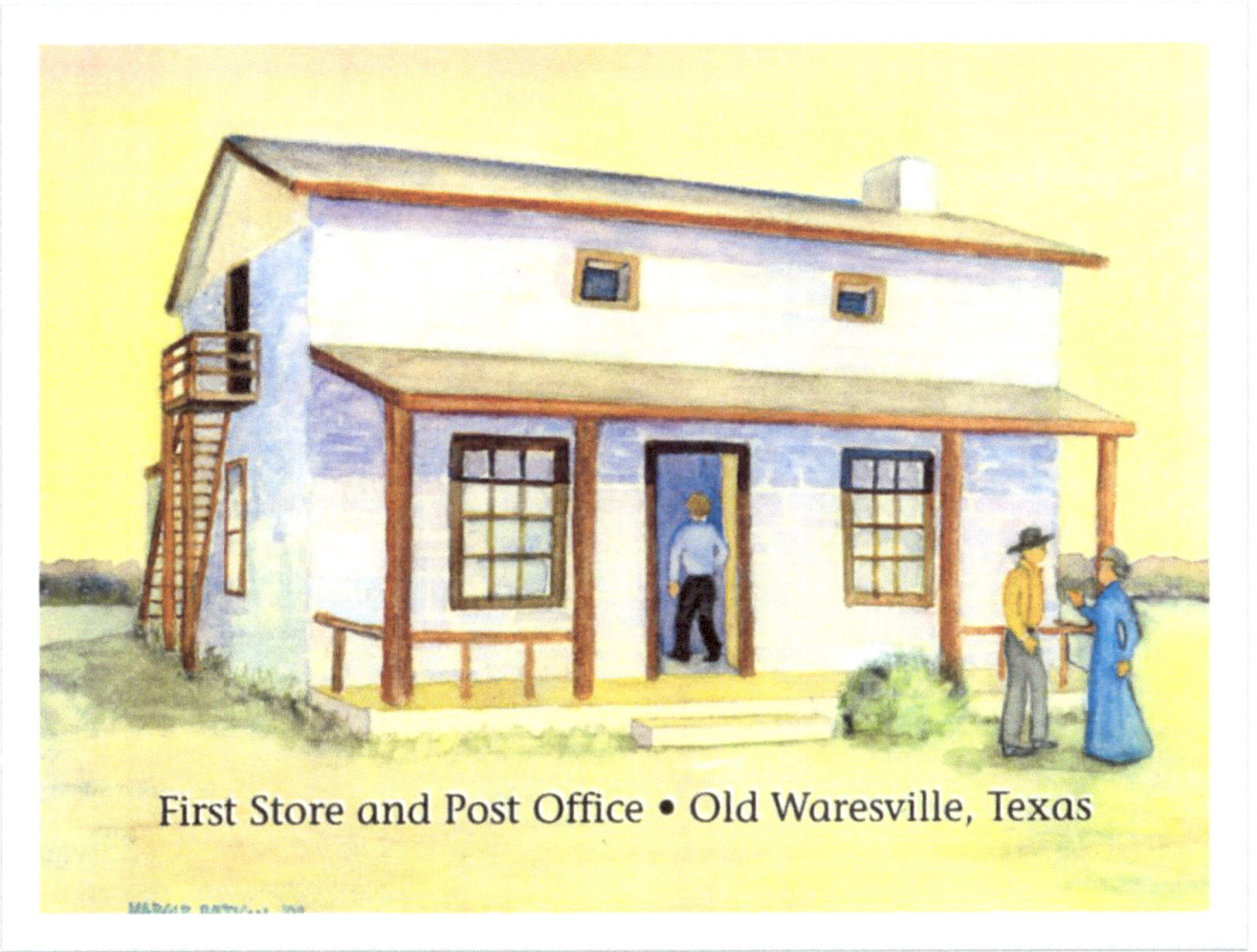

FIRST STORE AND POST OFFICE

Built of native stone by Charles Durbon in 1856. this is now a private residence.

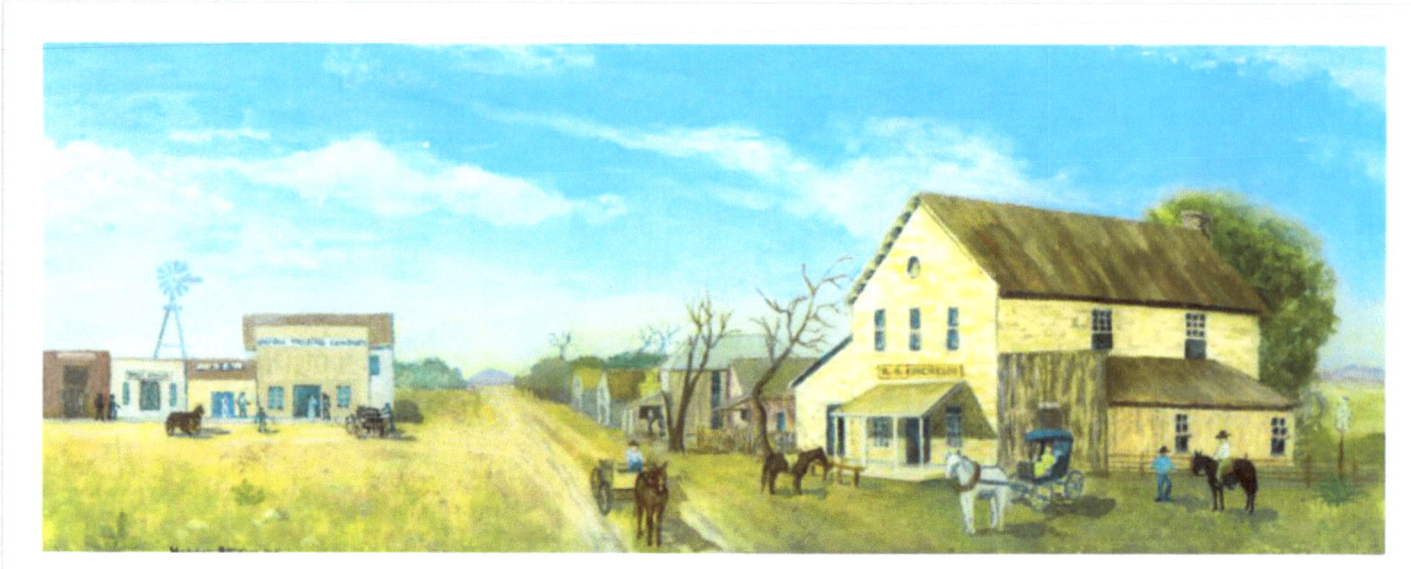

UTOPIA, TEXAS EARLY DAYS

Some say the name Utopia was suggested by Dr. Whitticar, while others believe it was proposed by the postmaster, George A. Barker.

After a raid by Kickapoo upon his home which left his neighbor's wife dead and his own wife, Sarah Ware Kincheloe, expected to die (she survived), ex-ranger Robert Kincheloe left his home on Little Creek and built the first building in what was to become the town of Utopia.

HILL COUNTRY

"You will find that this ancient home of the Apaches and Comanches has changed considerably since the time of William Ware, Gideon Thompson, and Aaron Anglin. Modern highways have swallowed the crude pioneer roads and now recline across the breast of the lovely valley like black serpents sprawled upon a giant shield of green. Sediment from cattle trails and upland farms has choked the once swift, silvery streams, so that some are now dry and others are less bold, a curse which the paleface has placed upon the primeval beauty of the land. The hated red man is gone, but the descendants of the pioneers are still there. Despite the scars left by one hundred years of tenure by the white man, the landscape is still one of surpassing beauty."

The Utopia Centennial Souvenir Booklet, 1952, reprinted for the Sesquicentennial

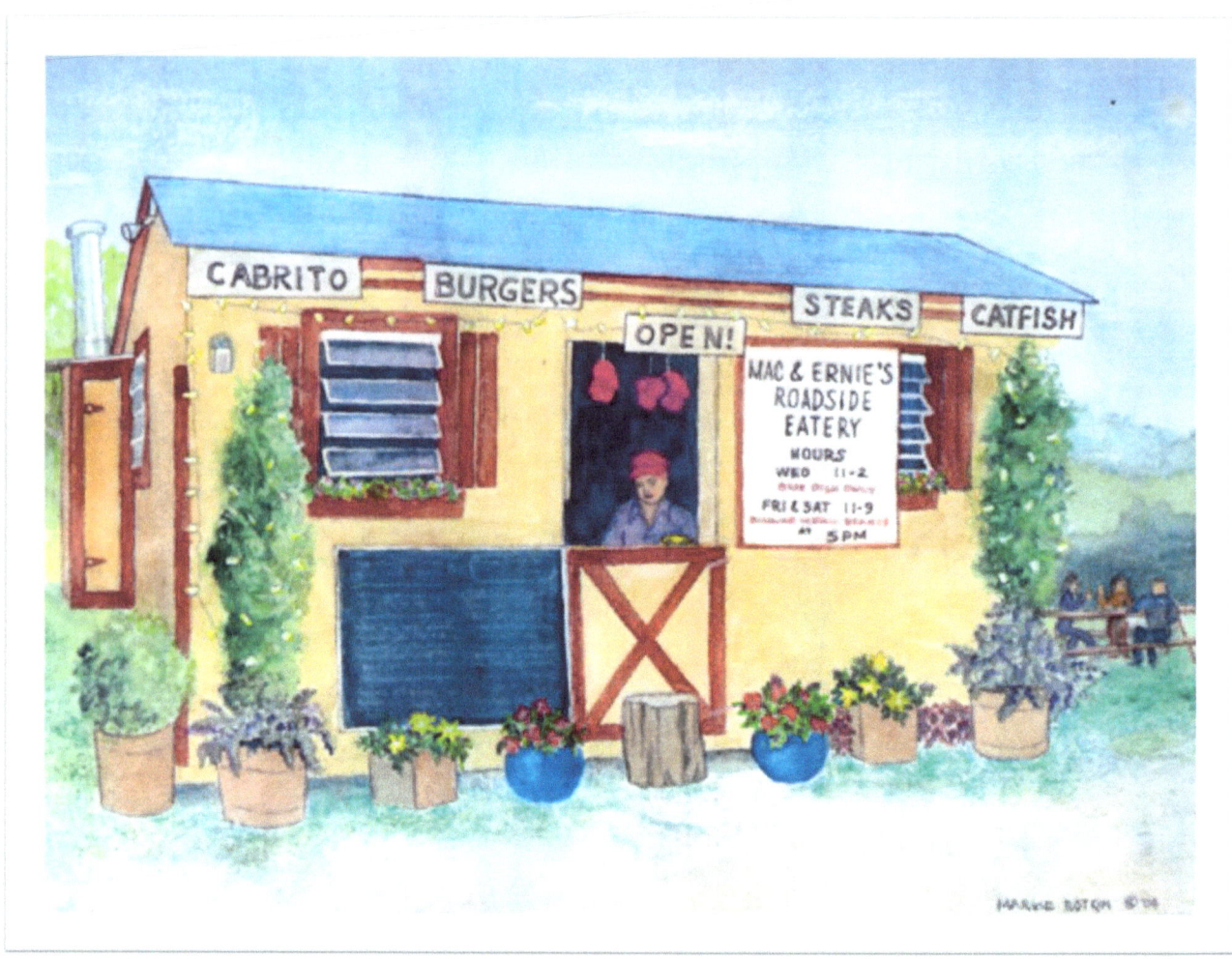

MAC & ERNIE'S ROADSIDE EATERY

This outdoor restaurant was located at Williams Creek in Tarpley, Texas. The eatery still exists in the town, but has moved indoors and across the street.

WILLIAMS CREEK DEPOT, TARPLEY, TEXAS

Local men still gather here for coffee and stories.

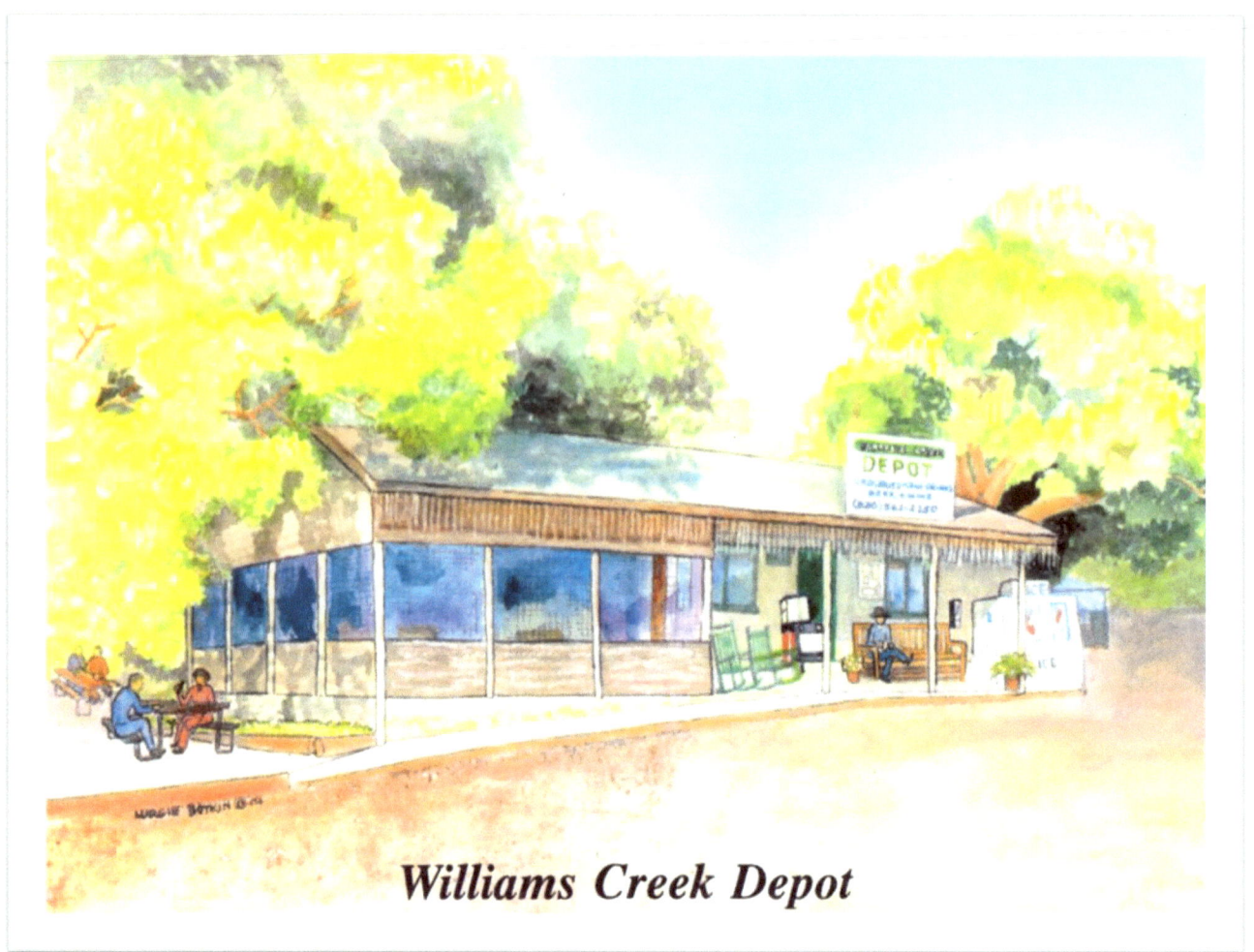

WILLIAMS CREEK DEPOT

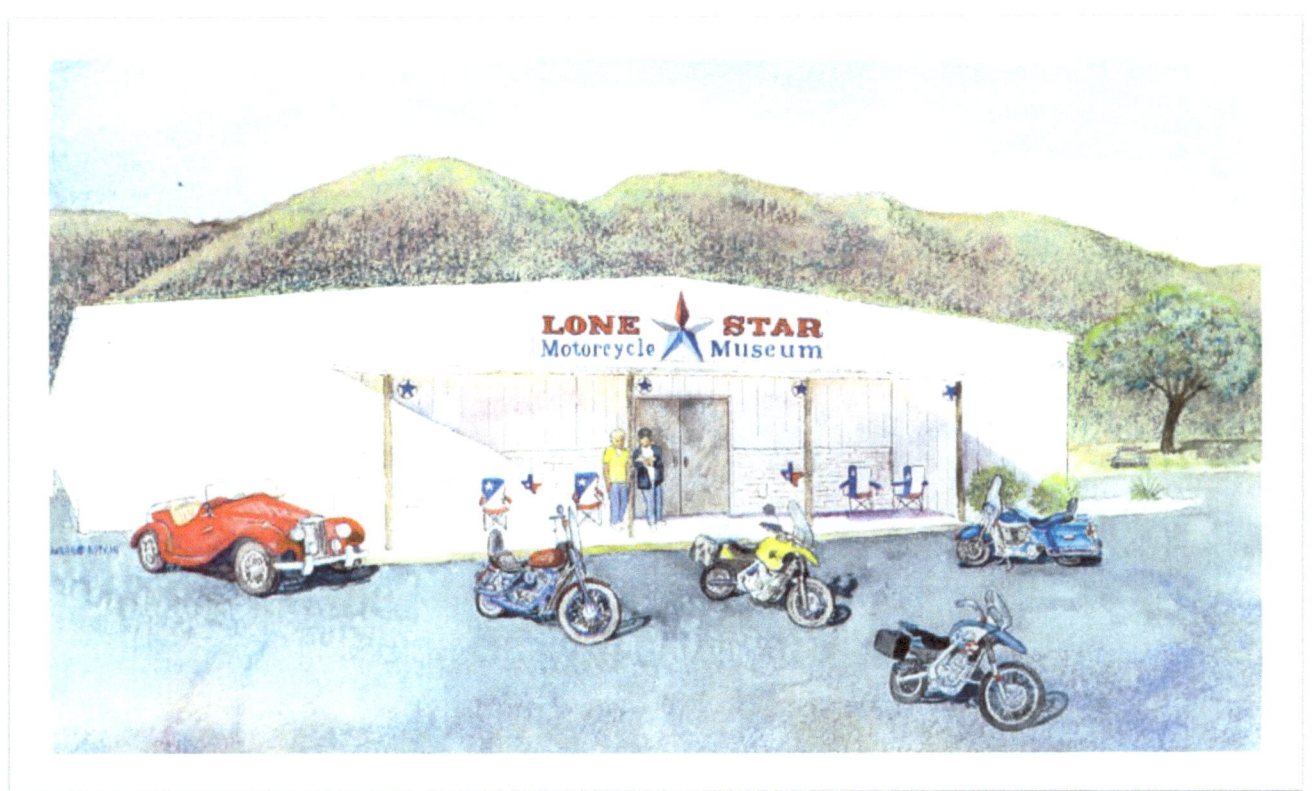

LONE STAR MOTORCYCLE MUSEUM

This museum in Vanderpool offers an interesting collection of historic motorcycles. Owners Alan (originally from Australia) and Debbie Johncock also serve hamburgers and Aussie Pies in the museum's Ace Café.

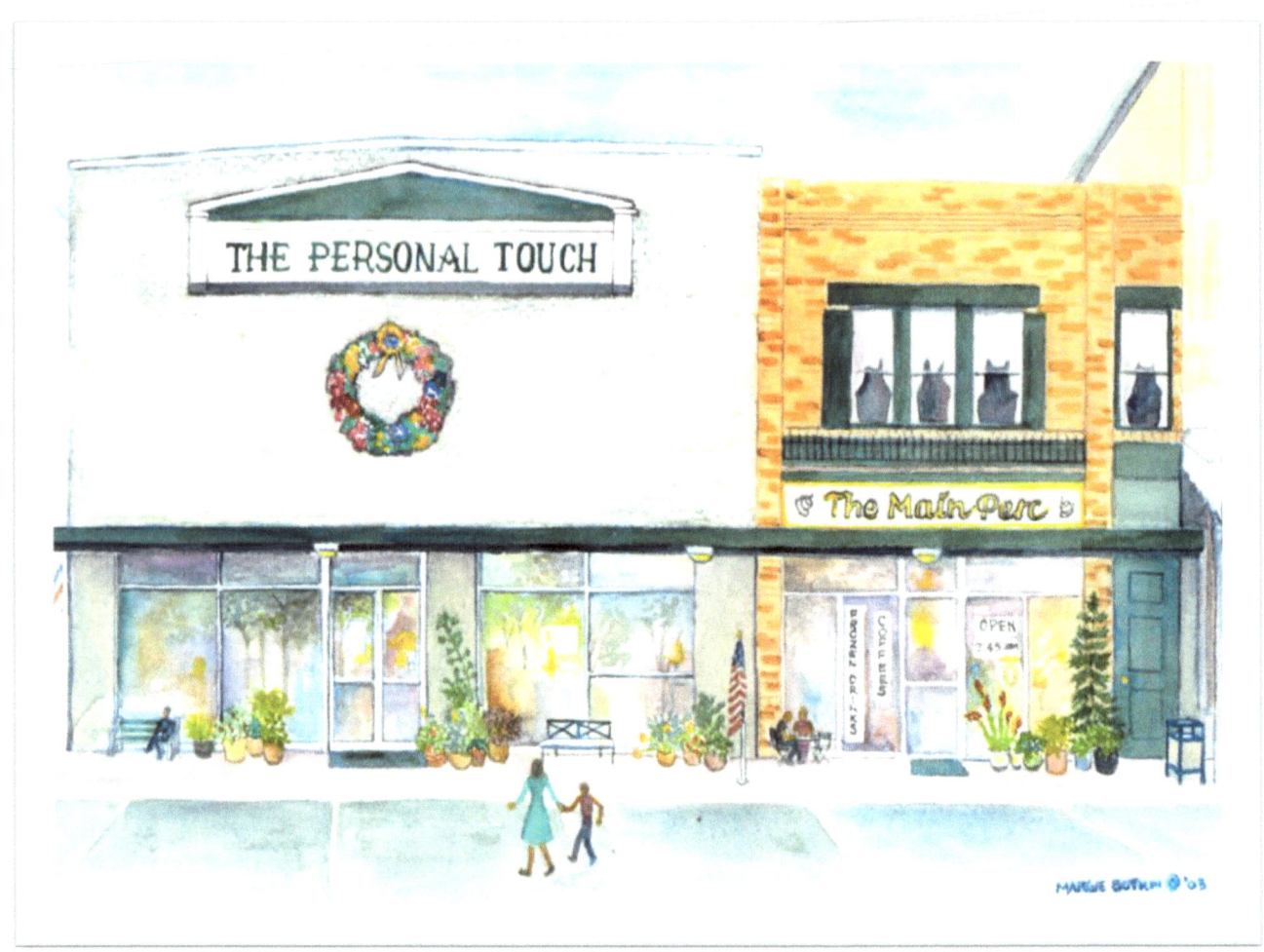

THE PERSONAL TOUCH AND THE MAIN PERC

These were located on the town square in Uvalde, Texas.

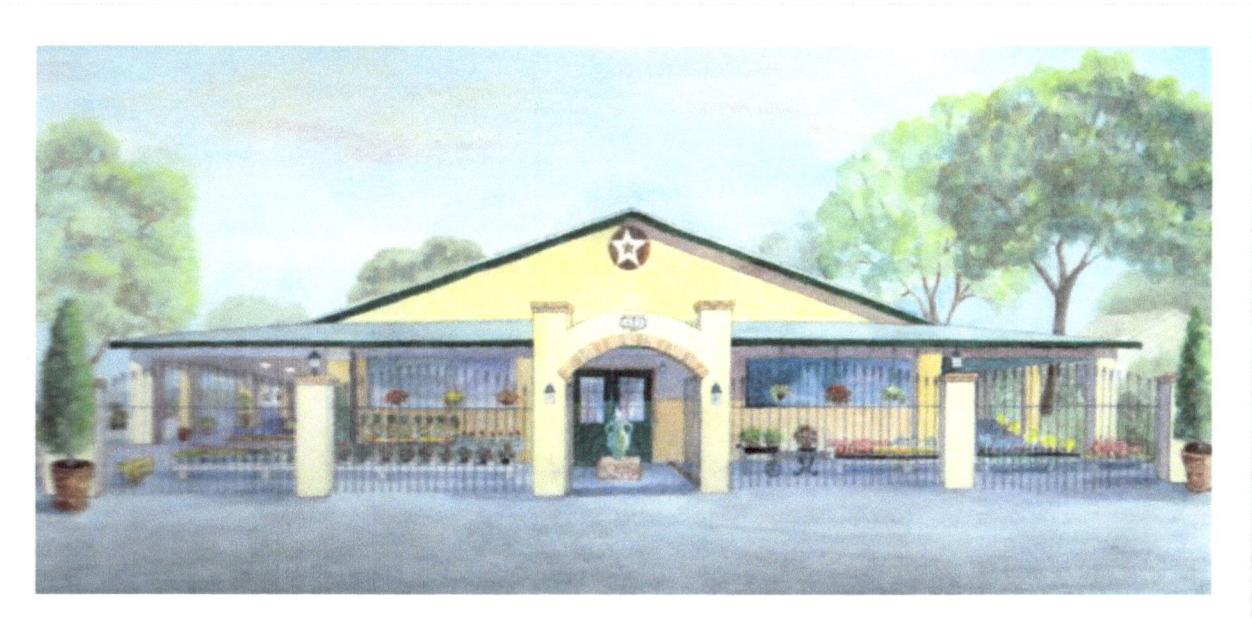

COUNTRY GARDENS & SEED

With a love of plants and gardening, Yolanda Moreno started this business with $200 and a fierce determination. Gonzalo L. Garcia, father of owners Johnny Joe and Yolanda Moreno, built this stucco block building.

TEXAS COLOR

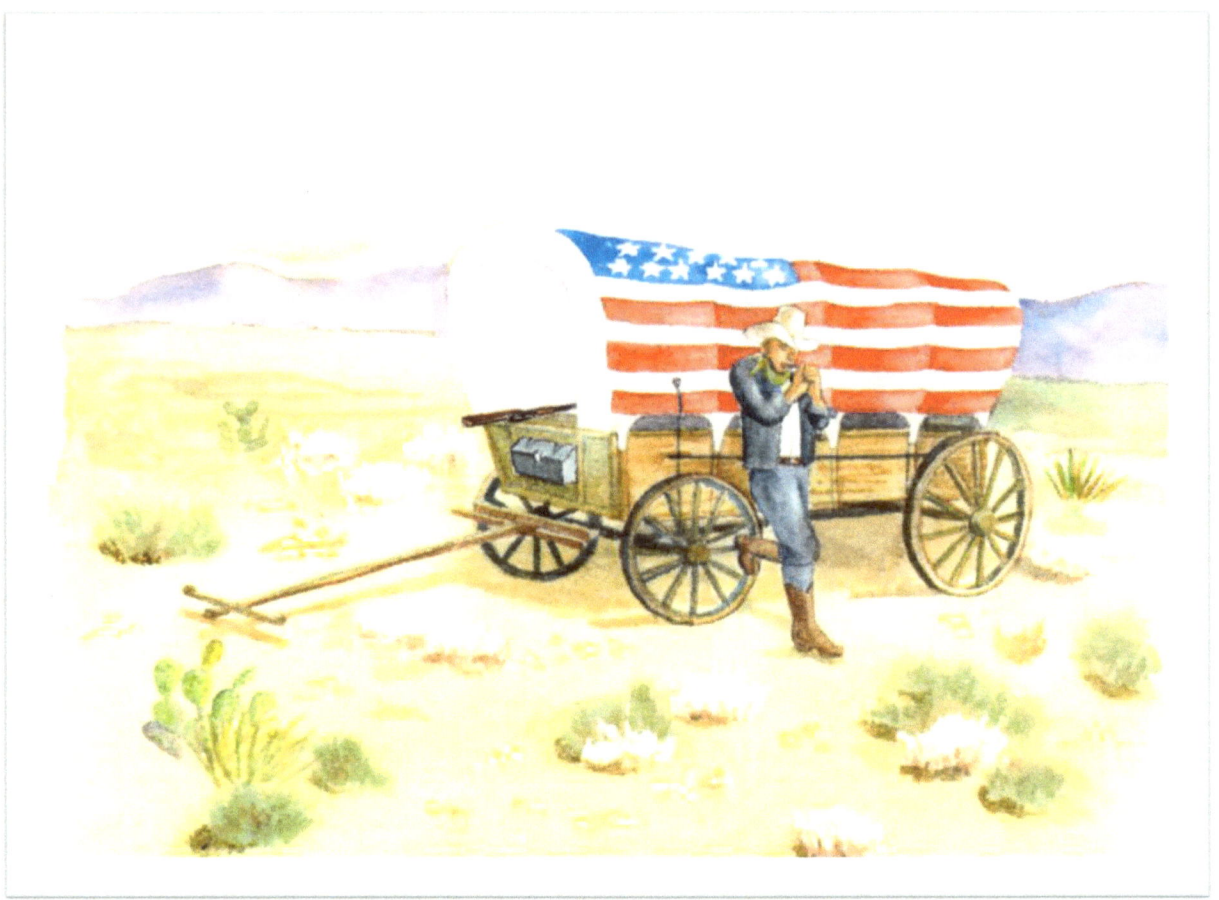

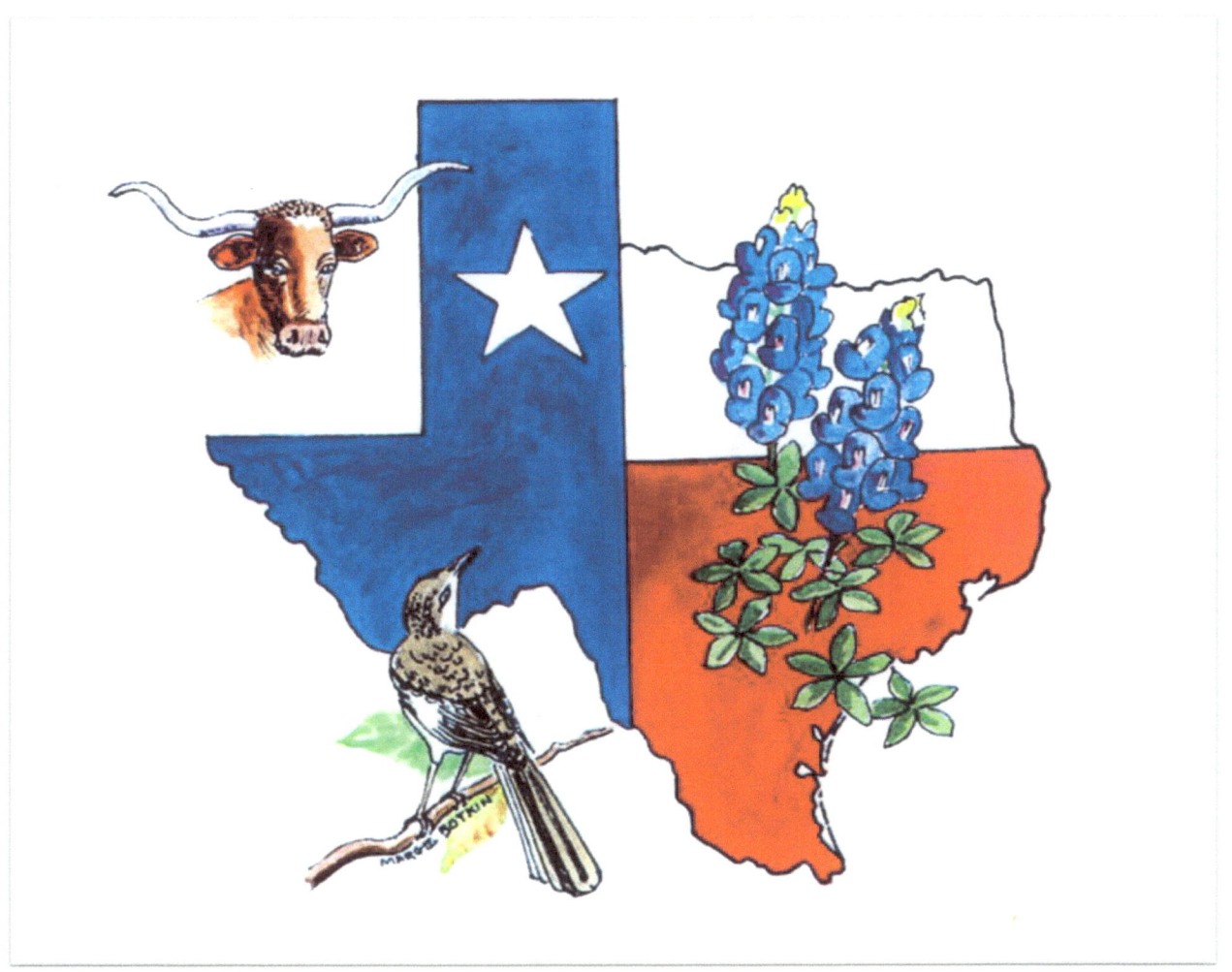

TEXAS COLORS

Longhorn cattle, bluebonnets (the state flower), and the mockingbird (the state bird).

ABOUT THE ARTIST

Margie Botkin grew up in Indianapolis, Indiana, and at the age of 18 moved to Chicago to attend the American Academy of Art and work as an apprentice in an advertising agency. She returned to Indianapolis and became the associate editor of a commercial trade magazine for L.S. Ayres & Co. department store, and later was hired as technical illustrator with the Civil Aeronautics Administration.

She married Rolan Botkin and in 1955 they moved to San Antonio, Texas, where he established his medical practice. During their years there Margie attended art and sculpture classes with John Squire Adams, Eva Templeton, Phil Evett, Luis Guzman, and Finis Collins, among others.

Upon Ron's retirement they moved to Utopia, Texas, where Margie has lived for more than two decades. The local history has always fascinated Margie and she has collected vintage photos and articles on the subject. She has painted many of the buildings and old homes, and her note cards and postcards are sold in local businesses and museums.

www.ingramcontent.com/pod-product-compliance
Lightning Source LLC
Chambersburg PA
CBHW050358180526
45159CB00005B/2066